Mary Engelbreit's

Let's Party

Mary Engelbreit's

Let's COOKBOOK Party

Illustrated by Mary Engelbreit

Photography by Mark Thomas

Andrews McMeel Publishing

Kansas City

www.andrewsmcmeel.com
www.maryengelbreit.com

 is a registered trademark of Mary Engelbreit Enterprises, Inc.

Library of Congress Cataloging-in-Publication Data
Engelbreit, Mary.
 Mary Engelbreit's let's party cookbook / illustrated by Mary Engelbreit ;
photography by Mark Thomas.--1st U.S. ed.
 p. cm.
 Includes index.
 ISBN 0-7407-1871-1
 1. Entertaining. 2. Cookery. I. Title: Let's party cookbook. II. Title.
TX731 .E54 2001
642'.4--dc21
 2001022374

First U.S. Edition
01 02 03 04 05 MON 10 9 8 7 6 5 4 3 2 1

Recipe developer: Judith Sutton
Designer: Amy Henderson

Produced by Smallwood & Stewart, Inc., New York City

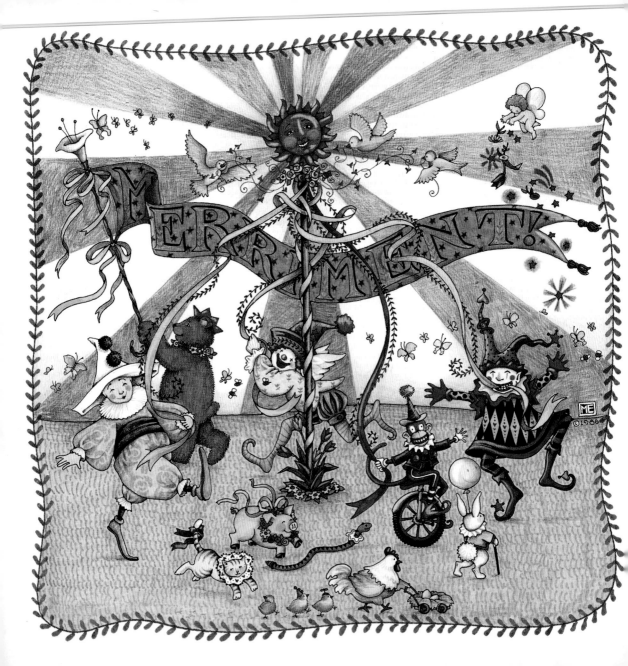

Do you deserve a party? I think you do. I think we all do. I think we all deserve more parties than we have, and this is the little book that will move us to celebrate more often. Everything that's needed for a party is within these pages: when to have one, what to serve, how to make it special.

Just follow Ann Estelle, "The Queen of the Kitchen," as she heads into the wonderful world of entertaining. Long admired as a person who needs no excuse to have a party, Ann Estelle has compiled her most inspiring ideas for hosting successful get-togethers for kids and grown-ups alike. Let's Party!

Mary

Let's Party

What do you need for a good party? The answer is simple: **GOOD GUESTS AND GOOD EATS**. You don't need a fancy kitchen or complicated decorations; most especially, you don't need to polish the silver. The more relaxed you are, the more your guests will enjoy themselves—and the more you will enjoy yourself. There are ways to **MAKE HOSTING A PARTY PURE PLEASURE**. Have a reason for your party, whether it is an honest-to-goodness one like a birthday or an anniversary, or something more capricious like strawberries coming into season. Turn an

occasion on its head: Instead of a Valentine's Day party on February 14th, have a party the week before and make Valentines with your friends.

Now you're ready for the best part: the food. Here are **THE QUEEN'S BEST RECIPES**, each and every one guaranteed to enhance your party enjoyment. We have recipes for kids and recipes for your most grown-up guests. Mix them or match them; present them as your own or give the credit to Ann Estelle. We think you'll enjoy them all.

Become famous for your parties. It's important to recognize **THE GOOD THINGS IN LIFE**.

CHARMED, I'M SURE

Tea Parties

Red Onion & Parsley Tea Sandwiches

Roast Beef Squares with Horseradish Cream

Avocado & Cucumber Spirals

English Gingersnaps

Easy Chocolate Truffles

Baby Cranberry Scones

Raspberry Jam Tartlets

Fudgy Brownie Squares

Ginger-Lemon Iced Tea

Moroccan Mint Tea

*T*ea parties are ever-so-civilized, and for good reason: They are asylum from the chaos of daily living. Tea and treats are as simple or fussy as you like; a tea party can be for a solitary tranquility-seeker or twenty good friends. With a clutch of posies, a bit of gentle music, and the companionship of friends or a good book, taking tea is a highlight of the afternoon.

Red Onion & Parsley
Tea Sandwiches

Looking for a delicate sandwich that epitomizes light tea fare? Here, little rounds of bread with the crusts removed (but of course!) sandwich thinly sliced red onions. The sides are swirled with mayonnaise, then rolled in minced parsley. If these are made a couple of hours in advance, refrigerate them, covered with plastic wrap.

SERVES 8 · MAKES 32 SANDWICHES

16 large slices firm white sandwich bread

About ¾ cup mayonnaise

2 small red onions, each sliced into 16 very thin rings

1 cup minced fresh flat-leaf parsley

1. With a 1¼-inch round cookie or biscuit cutter, cut 4 crustless rounds from each slice of bread; discard the scraps.

2. Spread a thin layer of mayonnaise over 1 side of each round of bread. Place 1 onion slice on 32 of the slices. The onion slices should be slightly smaller than the bread rounds—if necessary, discard outer rings to make the right size. Top with the remaining rounds of bread, mayonnaise-side down.

3. Put the parsley in a small shallow bowl. One at a time, holding each sandwich between your thumb and forefinger, spread a generous layer of mayonnaise over the edges of the sandwich. Roll the edges of the sandwich in the parsley, coating well. Place the sandwiches on a serving platter.

Red Onion & Parsley Tea Sandwiches; Roast Beef Squares with Horseradish Cream; Avocado & Cucumber Spirals

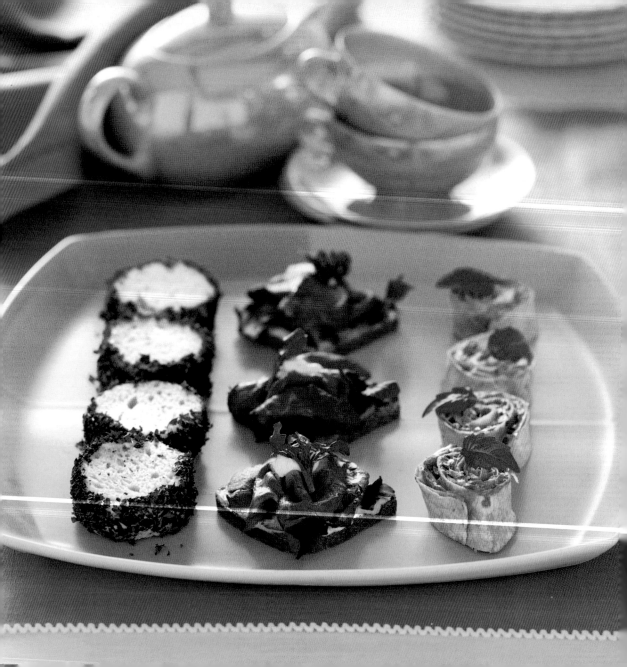

Roast Beef Squares
with Horseradish Cream

Roast beef and horseradish are a robust duo, and prepared as tiny tea nibbles are quite lovely. The horseradish cream can be made up to eight hours in advance; cover and refrigerate. This sandwich is also good with smoked chicken instead of roast beef.

SERVES 8 · MAKES 16 SQUARES

½ cup sour cream

2 to 3 tablespoons prepared horseradish

Salt and freshly ground pepper, preferably white, to taste

3 to 4 tablespoons mayonnaise

16 slices cocktail rye bread (about 2½-inches square)

Dijon mustard

1 cup loosely packed small watercress sprigs, plus 32 tiny leaves for garnish

6 ounces thinly sliced roast beef, trimmed

1. In a small bowl, combine the sour cream, horseradish, and salt and pepper, stirring until well blended. Cover and refrigerate for at least 30 minutes.

2. Spread the mayonnaise over the bread. Spread a little mustard over the mayonnaise. Arrange watercress sprigs on each slice. Place 1 or 2 slices of roast beef (depending on how thinly it was sliced) on each slice of bread. Arrange the squares on a platter, spoon a small dollop of horseradish cream on each, garnish with the watercress sprigs, and serve.

Avocado &
Cucumber Spirals

These California-style roll-ups are an alternative to the standard cucumber-and-butter
tea sandwiches. Lavash is a Middle Eastern flatbread available at most supermarkets.
If you prefer, use half a regular cucumber, seeded, in place of the English one.

SERVES 8 · MAKES ABOUT 34 SPIRALS

½ cup mayonnaise

2½ tablespoons minced fresh basil

Salt and freshly ground pepper

¼ English (seedless) cucumber, quartered
lengthwise and cut crosswise into thin slices

3 carrots, peeled and grated (generous 1 cup)

1 Hass avocado, peeled, pitted, and cut
into ¼-inch dice

1 sheet lavash bread (half a 14-ounce package)

Tiny basil leaves, for garnish

1. In a bowl, combine the mayonnaise and basil, blending well. Season with salt and pepper.

2. In a medium bowl, combine the cucumber, carrots, and avocado. Add the mayonnaise
mixture, tossing gently to coat. Season with salt and pepper.

3. Lay the lavash out flat and, with a serrated knife, trim it to about 14 by 19 inches. Cut
the bread lengthwise in half. Spread half the avocado filling evenly over one bread half, leav-
ing a 1-inch border on one of the longer sides and a ½-inch border along the other three
sides. Starting from the longside with the ½-inch border, roll the bread up jelly-roll fashion.
Place seam side down on a large plate. Repeat with the remaining filling and bread. Cover
and refrigerate for 30 minutes.

4. With a serrated knife, trim off the ends of the rolls. Cut the rolls into ¾-inch slices and
arrange the slices on a serving platter. Garnish each spiral with a basil leaf, and serve.

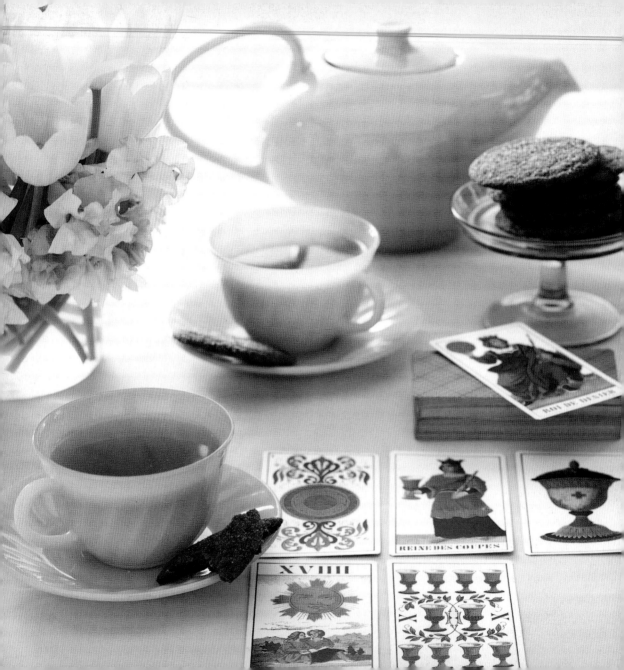

Tea Parties

Morning tea, elevenses, lunch tea, four o'clock tea, high tea—for every hour of the day, there is a tea ceremony that's appropriate. Whenever you decide to host your tea party, always remember that fun is the most important ingredient.

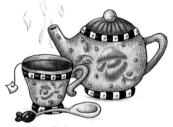

Feature Entertainment

Put a theme to your tea and it's even more enjoyable. There's a reason Mahjong and Tarot card reading have always been popular.

Host a shower tea, for a wedding, baby or housewarming, or for a more unconventional reason like graduation or a new job.

Try a Thé Dansant: twirl around to the music of tea orchestras; don't forget your white gloves!

HAVE QUALITY TEA There is a ritual to making a "proper" cup of tea. Choose good-quality loose tea. Prepare the tea by running cold water for a minute, then filling a kettle. As soon as the water boils, "hot the pot" by swirling some of the boiling water in the teapot. Toss this water and spoon in one tablespoon of tea leaves for each cup, plus one for the pot. Fill the teapot with boiling water. Allow the tea to steep for three to five minutes, then strain into teacups.

EXPERIMENT WITH TEA Nature has given us thousands of varieties—green, black, and orange pekoe to name a few. Try different teas and blends, and develop your palate. You'll be surprised how various teas complement certain foods.

THINK HOT AND COLD Don't be season-bound to summer ice and winter heat: Iced tea in front of a warming fire can be as refreshing as a glass of chilled white wine. And a hot cup of breakfast tea on a summer morning can prepare your body for the rising thermometer.

English *Gingersnaps*

Black pepper is the secret ingredient in real gingersnaps; they don't taste peppery, just delightfully spicy. Gingersnaps' flavor, which is not overly sweet, enhances all teas.

MAKES ABOUT 8 DOZEN COOKIES

2 cups all-purpose flour

2 teaspoons baking soda

2 teaspoons ground ginger

½ teaspoon ground cinnamon

½ teaspoon salt

⅛ teaspoon freshly ground pepper

¾ cup (1½ sticks) unsalted butter, at room temperature

1½ cups granulated sugar

½ cup packed light brown sugar

1 large egg

¼ cup dark molasses

1. In a medium bowl, combine the flour, baking soda, ginger, cinnamon, salt, and pepper.

2. In a large bowl, beat the butter, ½ cup granulated sugar, and the brown sugar with an electric mixer at medium speed until light and fluffy. Beat in the egg, blending well, then beat in the molasses. On low speed, beat in the flour mixture in 2 additions. Cover and refrigerate until firm, about 2 hours.

3. Preheat the oven to 350°F. Grease 2 heavy baking sheets.

4. Put the remaining 1 cup granulated sugar in a small shallow bowl. Using about 1 level teaspoon per cookie, roll the dough into scant 1-inch balls, then roll in the sugar, coating well, and place 2 inches apart on the prepared baking sheets.

5. Bake the cookies for 9 to 11 minutes, or until they are flat and crinkled and the edges are very slightly browned. Let cool on the pans on wire racks for 1 to 2 minutes, then transfer to the racks to cool completely.

Easy Chocolate *Truffles*

The chocolate mixture—called ganache—is made in a food processor, chilled, then simply cut into sleek truffle squares.

MAKES 3 DOZEN TRUFFLES

8 ounces bittersweet chocolate, coarsely chopped

½ cup heavy cream

1 teaspoon vanilla extract

About ¼ cup unsweetened cocoa powder, sifted, for dusting

1. Line an 8-inch square baking pan with aluminum foil, allowing the foil to extend over 2 opposite sides. In a food processor, process the chocolate until finely chopped.

2. In a small saucepan, bring the cream just to a boil over medium heat. With the motor running, carefully pour the hot cream into the food processor and process just until the chocolate is melted and the mixture is smooth; stop once or twice to scrape down the sides of the container. Add the vanilla and pulse to blend.

3. Transfer the mixture to the prepared pan and let cool to room temperature. Cover and place in the freezer until set and fairly firm, 3 to 4 hours.

4. Using the foil overhang as handles, lift the chocolate slab out of the pan and invert it onto a cutting board. Carefully peel off the foil. With a sharp heavy knife, cut the chocolate slab into 36 squares. If the chocolate begins to soften too much, return to the freezer briefly. Place the truffles on a plate, cover, and refrigerate until shortly before serving.

5. Spread the cocoa on a plate. Dredge the truffles in the cocoa, turning to coat. Arrange the truffles on a plate and serve, or refrigerate, loosely covered, for up to 30 minutes before serving. The cocoa powder will dissolve into the truffles if they stand longer, but you can recoat them if necessary. Cover and refrigerate any leftover truffles.

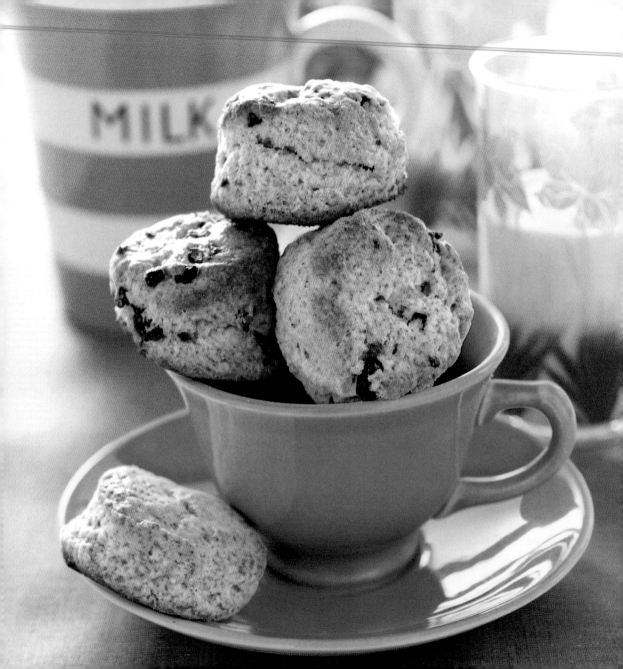

Baby Cranberry Scones

Scones come in many shapes, from hefty triangles to squares; these are dainty rounds. Rich clotted cream is a traditional accompaniment, but these are so buttery they are really fine on their own.

MAKES ABOUT 26 SCONES

2 cups all-purpose flour

⅓ cup sugar

1 tablespoon baking powder

½ teaspoon salt

½ cup (1 stick) cold unsalted butter, cut into ½-inch cubes

¾ cup heavy cream, plus 1 to 2 tablespoons for brushing

½ cup sweetened dried cranberries, coarsely chopped

1. Preheat the oven to 425°F. Butter and flour 2 baking sheets.

2. In a large bowl, whisk together the flour, sugar, baking powder, and salt. With a pastry blender, 2 knives, or your fingertips, cut in the butter until the pieces of butter are no larger than tiny peas. With a fork, stir in the ¾ cup cream just until a shaggy dough forms.

3. Turn the dough out onto a lightly floured surface, top with the cranberries, and knead briefly, just until the dough forms a ball and the cranberries are incorporated; do not overwork. Quickly and gently pat the dough out into a ¾-inch-thick round. With a 1½-inch round biscuit cutter, cut as many rounds as possible from the dough and place 1½ inches apart on the prepared baking sheets. Gather the scraps of dough and knead together briefly, then pat out and cut out more scones. Brush the tops of the scones with the cream.

4. Bake for 13 to 15 minutes, or until the scones have risen and are golden brown. Transfer to wire racks to cool slightly and serve warm, or let cool to room temperature.

Raspberry *Jam Tartlets*

These sweet little jam tartlets are made simply by pressing dough into mini-muffin cups; jam is spooned into tart shells warm from the oven. To add cut-out pastry decorations, see the Note following the recipe.

MAKES 2 DOZEN TARTLETS

I cup all-purpose flour

3½ tablespoons confectioners' sugar

Pinch of salt

6 tablespoons (¾ stick) cold unsalted butter, cut into ½-inch cubes

2 to 3 tablespoons ice water

½ cup seedless raspberry jam

1. Make the pastry: Combine the flour, confectioners' sugar, and salt in a food processor and pulse to blend. Scatter the butter over the flour and pulse 10 to 15 times, until the mixture resembles coarse meal. Add 2 tablespoons ice water and pulse until the dough just starts to come together, adding up to 1 tablespoon more ice water if necessary. Divide the dough in half (or thirds, if you are making cut-outs). Shape each piece of dough into a cylinder, wrap in plastic wrap, and refrigerate for 30 minutes.

2. Set out two 12-cup mini-muffin pans. Divide two cylinders of dough into 12 equal pieces each. Roll each piece into a ball, then flatten it between your palms into a round about 2 inches in diameter. Fit 1 round into each muffin cup, pressing it with your fingertips so that it comes up to the rim of the cup. Refrigerate the tartlet dough for 15 to 30 minutes, until it is chilled and firm.

3. Preheat the oven to 350°F. Prick the bottom of each tartlet shell 2 or 3 times with a fork. Bake the tartlets until they are golden brown, 15 to 17 minutes. Place the tins on wire racks to cool slightly. Remove the tartlet shells from the pans.

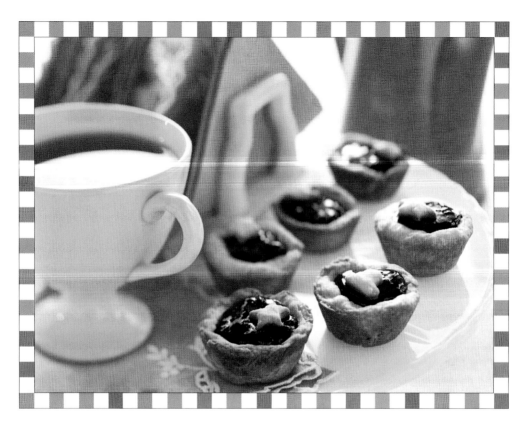

4. Spoon 1 level teaspoon of the jam into each warm tartlet shell. Serve the tarts slightly warm or at room temperature.

NOTE

To make cut-outs, increase the pastry recipe by half. On a floured surface, roll the reserved dough to a ¼-inch thickness. Cut out shapes using small cutters and place on an ungreased baking sheet. Bake for 4 to 6 minutes. Cool on a wire rack and press 1 onto each tart.

Fudgy *Brownie* Squares

Be warned: These little brownie squares may look innocent, but they pack a giant chocolate wallop! Because they are so rich and intense, we recommend cutting them into modest one-inch squares.

MAKES 8 DOZEN SQUARES

1 cup (2 sticks) unsalted butter

6 ounces unsweetened chocolate

4 large eggs

1½ cups granulated sugar

¾ cup packed dark brown sugar

¼ teaspoon salt

1½ teaspoons vanilla extract

1 cup all-purpose flour

1½ cups semisweet chocolate chunks or large semisweet chocolate chips

1. Preheat the oven to 350°F. Grease a 9- by 13-inch baking pan.

2. Combine the butter and unsweetened chocolate in a medium heavy saucepan and melt over low heat, stirring frequently just until smooth. Remove from the heat.

3. In a large bowl, beat the eggs and both sugars with an electric mixer at medium speed until smooth and thick, 2 to 3 minutes. Beat in the salt. Beat in the melted chocolate mixture, then beat in the vanilla. On low speed, beat in the flour in 2 additions. Stir in the chocolate chunks. Pour the batter into the prepared pan and smooth the top.

4. Bake the brownies for 28 to 32 minutes, or until a toothpick inserted in the center just comes out clean. Let cool completely on a wire rack. With a large, heavy, sharp knife, cut the brownies into 96 one-inch squares.

Ginger-Lemon *Iced Tea*

Ginger is often considered an acquired taste, but for grown-ups it can become addictive.
It has a distinctive and versatile flavor that works well with tea. In this recipe,
it combines with fresh lemon juice to make an especially refreshing accompaniment
to sweet morsels like truffles and brownies.

SERVES 8

16 tea bags

One 2-inch piece ginger, cut into ⅛-inch slices

6 cups boiling water

¼ cup fresh lemon juice

Sugar, to taste

Ice cubes

8 thin slices lemon, for garnish

1. Tie the strings of the tea bags together for easy retrieval and place the bags and ginger in a large heatproof pitcher. Add the boiling water and let steep for 3 minutes. Remove and discard the tea bags; let the tea cool to room temperature.

2. Add the lemon juice and sugar to the tea, or leave the sweetening to your guests. Pour the tea into tall ice-filled glasses, garnish each with a lemon slice, and serve.

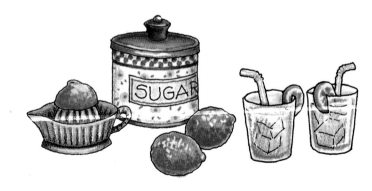

Moroccan *Mint Tea*

In Morocco, mint tea is offered to guests as a sign of hospitality, but Moroccans drink the very sweet, fragrant tea all through the day. It's usually presented in small glasses, but cups will do fine. Traditionally a hot beverage, it is delicious cold—allow it to steep for ten minutes, then strain, cool, and chill; serve over ice.

SERVES 8

1 large bunch fresh mint (about 1 ounce)

4 cups boiling water, plus about 1 cup for heating the teapot

1 tablespoon loose green tea

6 to 8 tablespoons sugar

1. Trim the coarse stems from the mint. Reserve 8 small sprigs for garnish and gently crush the remaining sprigs with your hands.

2. Pour about 1 cup boiling water into a teapot, swirling it around to heat the pot, then drain. Add the tea leaves, 6 tablespoons of the sugar, and the crushed mint sprigs to the pot. Pour in the 4 cups boiling water, cover, and let steep for 5 minutes, stirring once or twice to dissolve the sugar.

3. Taste the tea and add up to 2 more tablespoons sugar if desired. Cover and let steep for 2 to 3 minutes longer, stirring once.

4. Strain the tea into small heatproof glasses, garnish each one with a mint sprig, and serve.

When they're in season, succulent, ruby-red strawberries deserve their own party. If you are near **a strawberry farm**, harvest as much as you can. Once you've made **all these fabulous dishes**, freeze any leftover berries in airtight bags.

Strawberries & Cream

Rich cream, just barely sweetened, allows the juicy ripe strawberries to shine.

SERVES 8

1 cup heavy cream

1 tablespoon sugar, or to taste

2 pints strawberries, hulled and quartered

8 small mint sprigs, for garnish

1. In a large bowl, beat the cream and sugar with an electric mixer at medium-high speed until slightly firm peaks just begin to form. Cover and refrigerate until ready to use.

2. Divide the strawberries among individual glass dessert dishes. Top with the whipped cream, garnish each serving with a mint sprig, and serve.

Strawberry Fool

If you know anyone who is a fool for strawberries, this will be nirvana: The sublime combination of strawberries and cream is taken to the next level.
Recently strawberries in pound containers have begun to appear in the market;
by all means, use the whole pound here.

SERVES 8

1 pint strawberries, hulled and quartered

¼ cup sugar, or to taste

2 cups heavy cream

8 strawberries with stems, for garnish

1. In a food processor, combine the strawberries and sugar and process to a slightly coarse puree. The puree should be quite sweet, so add more sugar if necessary.

2. In a large bowl, beat the cream with an electric mixer at medium-high speed just until it holds firm peaks. With a large rubber spatula, gradually fold in the strawberry puree just until blended. Transfer the fool to a serving bowl or individual glass dishes, cover, and refrigerate for 1 to 2 hours.

3. Arrange the strawberries for garnish around the edge of the serving bowl or slice the berries and place 1 on each individual portion. Serve chilled.

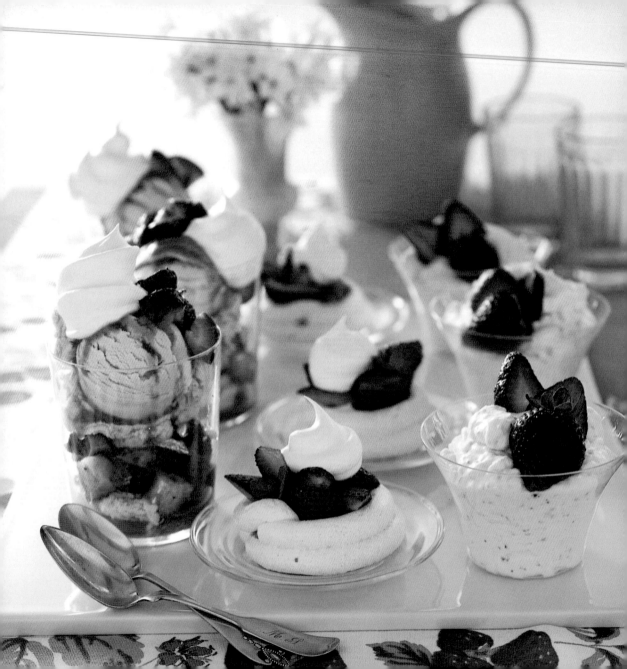

Fresh *Strawberry Parfaits*

A glistening sauce made with ripe juicy berries and a surprise of diced berries between layers of ice cream make for parfait perfection.

SERVES 8

STRAWBERRY SAUCE

1 pint strawberries, hulled and quartered

2 tablespoons sugar, preferably superfine, or to taste

½ teaspoon fresh lemon juice

1 cup heavy cream

2 tablespoons sugar

1½ quarts vanilla ice cream

½ cup diced strawberries (about 8 medium)

1. Make the strawberry sauce: In a food processor or blender, process the strawberries to a smooth puree. Strain through a fine-mesh strainer into a bowl, pressing on the solids to release as much liquid as possible; discard the solids. Stir in the sugar and lemon juice. Cover and refrigerate until chilled.

2. In a medium bowl, beat the cream with the sugar in an electric mixer at medium-high speed just until slightly firm peaks begin to form. Cover and refrigerate the cream until ready to use.

3. Assemble the parfaits: Place ¼ cup of ice cream in the bottom of each of 8 parfait or stem glasses and top with about 1 tablespoon of strawberry sauce. Place another ¼ cup of ice cream in each glass and scatter 1 tablespoon of diced strawberries over each scoop. Repeat with another layer of ice cream, sauce, and strawberries, then top with the whipped cream. Serve the parfaits immediately.

Strawberries in
Meringue Nests

In France, these meringues are called vacherins, shaped like little bird's nests to hold all kinds of sweet surprises. Once you have the knack of piping meringue (it does take a bit of practice), your guests will think you've been studying at a school for professional pastry chefs.

SERVES 8

MERINGUE NESTS

3 large egg whites, at room temperature

¾ cup sugar

½ teaspoon vanilla extract

2 pints strawberries, hulled and halved (or quartered if large)

2 tablespoons framboise (black raspberry liqueur) or 1 tablespoon sugar

Sweetened whipped cream, for garnish

Mint sprigs, for garnish

1. Make the meringue nests: Position a rack in the lower third of the oven and preheat the oven to 250°F. Butter and flour a large baking sheet. Using a 2½-inch round cutter (or a small knife), trace 8 circles on the baking sheet, about 2 inches apart.

2. In a large bowl, beat the egg whites with an electric mixer on low speed until frothy. Increase the speed to medium-high and beat until the whites begin to form soft peaks. Add ½ cup of the sugar 1 tablespoon at a time, beating until the whites form stiff, glossy peaks. With a large rubber spatula, gently fold in the remaining ¼ cup sugar 1 tablespoon at a time.

Strawberry Fans

Strawberry fans are colorful garnishes for cakes, tarts, even omelettes. To make them, choose well-shaped ripe strawberries, preferably with stems. Do not hull. With a sharp paring knife, make a series of lengthwise parallel cuts in each berry, keeping the slices attached at the stem end. Carefully and gently press down on each berry to fan out the slices slightly.

3. Transfer the meringue to a large pastry bag fitted with a large plain tip. Following the circles traced on the baking sheet as a guide, pipe 8 rings of meringue, then pipe a spiral of meringue inside each circle to fill it in. Pipe a second ring of meringue onto each circle to create a shallow nest.

4. Bake the meringues for 60 to 75 minutes, or until thoroughly dry. Turn off the oven and let the meringues cool completely in the oven, 30 minutes to 1 hour.

5. In a medium bowl, combine the strawberries and the liqueur and let stand for 30 minutes, stirring 2 or 3 times.

6. Place the meringue nests on individual plates and spoon the strawberries, with their juices, into them. Garnish with whipped cream and mint sprigs. Serve immediately.

Strawberry Layer Cake

It's old-fashioned; it's the essence of layer cakes; and it's simply gorgeous.
Here is the showstopper finale to your strawberry festival.

SERVES 10 TO 12

CAKE

2¾ cups all-purpose flour

1 tablespoon baking powder

½ teaspoon salt

¾ cup (1½ sticks) unsalted butter,
at room temperature

2 cups sugar

4 large eggs

1½ teaspoons vanilla extract

1½ cups milk

WHITE CHOCOLATE FROSTING

2 cups heavy cream

7 ounces good-quality white chocolate,
coarsely chopped

5 tablespoons seedless strawberry jam

10 to 12 small strawberries, for garnish

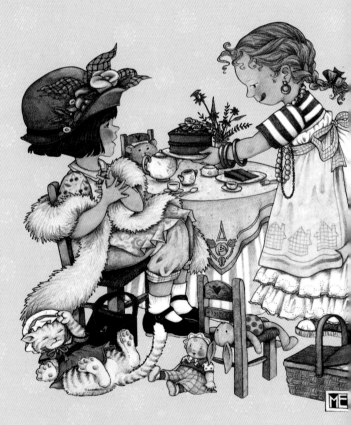

1. Make the cake: Preheat the oven to 350°F. Grease and flour three 9-inch round cake pans.

2. In a large bowl, whisk together the flour, baking powder, and salt.

3. In another large bowl, beat the butter and sugar with an electric mixer at medium speed until the mixture is light and fluffy, about 3 minutes. Beat in the eggs 1 at a time, beating well after each addition. Beat in the vanilla. On low speed, alternately beat in the flour mixture and the milk, beginning and ending with the flour mixture. Pour the batter into the prepared pans and smooth the tops with a rubber spatula.

4. Bake for 23 to 25 minutes, or until a toothpick inserted in the center comes out clean. Let the cakes cool in the pans on wire racks for 10 minutes. Invert the layers onto the racks, turn right side up, and let cool completely.

5. Make the white chocolate frosting: In a small heavy saucepan, combine ½ cup of the cream and the white chocolate. Cook over low heat, stirring frequently, until the mixture is smooth. Let cool to room temperature, stirring once or twice.

6. In a large bowl, beat the remaining 1½ cups cream until it just starts to hold soft peaks. On low speed, beat in the chocolate mixture and continue to beat until firm peaks barely begin to form. Cover and refrigerate for 15 minutes, or until the mixture is starting to set.

7. Brush any loose crumbs from the cake layers. Place 1 layer upside down on a serving plate. Spread 2½ tablespoons of jam evenly over the top, leaving a ½-inch border all around. Spread ½ cup of the white chocolate frosting over the jam. Refrigerate the cake layer and the remaining frosting for 15 minutes. Spread the remaining 2½ tablespoons jam over the second cake layer, leaving a ½-inch border, and place on top of the first. Spread ½ cup of the white chocolate frosting over the top and refrigerate for 10 minutes.

8. Place the third cake layer on top of the cake and frost the top and sides with the remaining frosting. Arrange the strawberries evenly around the top of the cake. Refrigerate for 2 to 4 hours before serving. Refrigerate any leftovers.

SMALL WONDERS

Parties for Kids

Creamy Deviled Eggs

Grilled-Cheese Sandwiches

Cheese Pizzettes

Honey-Glazed Chicken Wings

Itty-Bitty Barbecued Beef Burritos

Party Trail Mix

Chocolate-Frosted Cupcakes

Fudgy Brownie Sundaes

Peanut Butter Bars

Summer Sunrise

Raspberry-Pineapple Fruit Punch

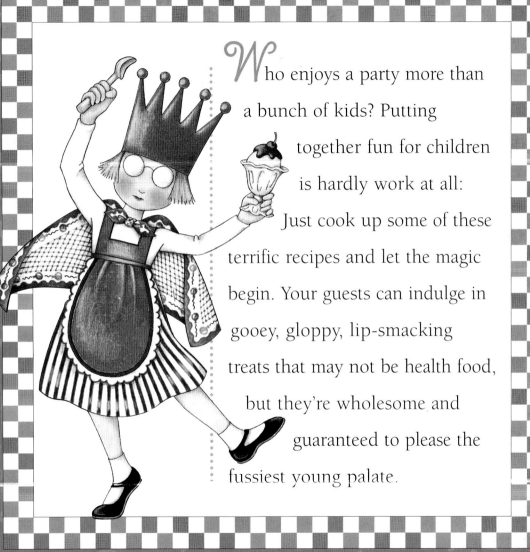

Who enjoys a party more than a bunch of kids? Putting together fun for children is hardly work at all: Just cook up some of these terrific recipes and let the magic begin. Your guests can indulge in gooey, gloppy, lip-smacking treats that may not be health food, but they're wholesome and guaranteed to please the fussiest young palate.

Creamy *Deviled Eggs*

Deviled eggs may seem a bit retro, but kids love them. With their little white cups and mounded yolk filling, they're far more fun to eat than plain hard-cooked eggs. If you have older children, they may want to try piping the filling into the cups.

SERVES 8

8 large eggs

½ cup mayonnaise

½ teaspoon Dijon mustard

¼ teaspoon salt

⅛ teaspoon freshly ground pepper

Paprika, for garnish

Snipped fresh chives, for garnish

1. Put the eggs in a large saucepan, add cold water to cover by about 1 inch, and bring just to a boil over medium heat. Boil gently for 3 minutes, then turn off the heat, cover the pan, and let the eggs stand in the hot water for 12 minutes.

2. Drain the eggs, cover with cold water, and let stand until cool. Drain again and refrigerate until ready to use.

3. Peel the eggs and, with a sharp knife, halve lengthwise. Scoop out the yolks and transfer to a food processor. Set the whites aside. Add the mayonnaise, mustard, salt, and pepper to the yolks, and process until smooth. Transfer the yolk mixture to a pastry bag fitted with a medium star tip, or transfer to a bowl.

4. Pipe or spoon about 1 tablespoon of the egg yolk mixture into each egg white half, mounding it slightly in the center. Place the eggs on a large plate, cover loosely with plastic wrap, and refrigerate until ready to serve.

5. Arrange the eggs on a serving platter or pedestal cake stand. Sprinkle paprika and chives over the filling.

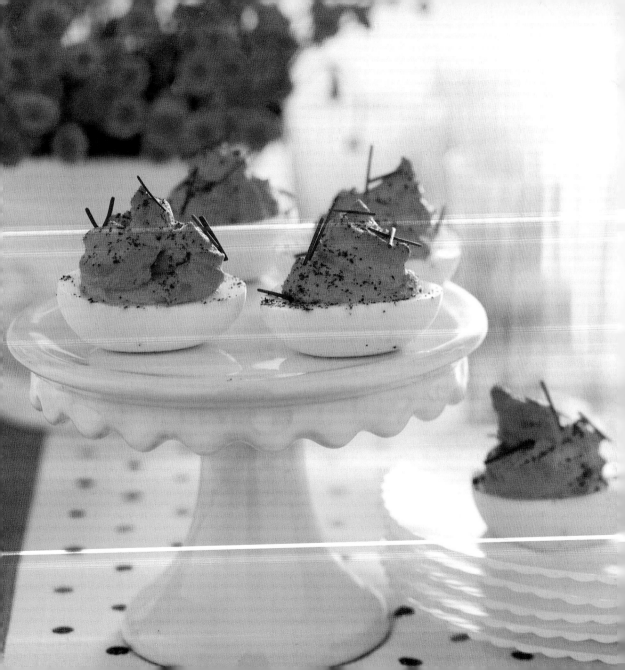

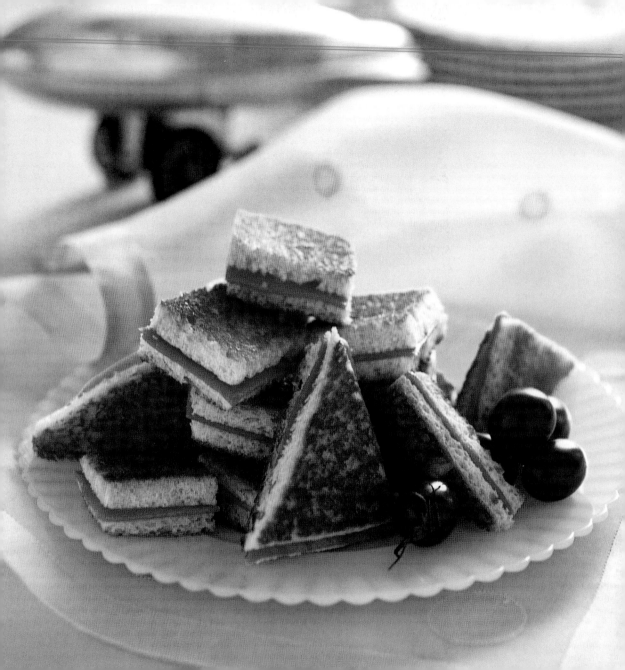

Grilled-Cheese
Sandwiches

*Baby grilled-cheese sandwiches are somehow more festive than ordinary ones.
Try cutting these into fun and interesting shapes—stars, hearts or diamonds—
before baking. A mild Cheddar or American cheese is the best choice.*

SERVES 8 - MAKES 32 MINI-SANDWICHES

¼ cup (½ stick) butter, at room temperature

12 slices firm white sandwich bread, crusts removed

5 ounces mild Cheddar cheese, thinly sliced (about ³⁄₁₆ inch thick)

1. Position a rack in the upper third of the oven and preheat the oven to 400°F.

2. Spread half the butter evenly over 6 slices of bread. Arrange the remaining 6 slices of bread on a work surface and cover with the cheese. Place a buttered slice of bread on each, buttered side up, and cut the sandwiches into quarters or triangles. Arrange them, buttered side down, on a large baking sheet, and spread the remaining butter over the tops.

3. Bake for 4 to 5 minutes, or until the sandwiches are light golden brown on the bottom and the cheese is starting to melt. With tongs or a spatula, turn the sandwiches over and bake until they are golden brown on the second side, about 3 minutes. Let cool briefly before serving.

Cheese *Pizzettes*

*These little pizzas take only minutes to assemble and bake. Kids can
even add their own favorite toppings before you slip the pizzettes into the oven.
We call this Satisfaction Guaranteed.*

MAKES 8 PIZZETTES

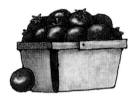

One 10-ounce tube refrigerated pizza dough

½ cup tomato pizza or pasta sauce

¾ cup grated mozzarella cheese

1. Preheat the oven to 425°F. Unroll the pizza dough, cut it into 8 equal pieces, and form each piece into a rough ball. Place 1 ball on an ungreased baking sheet and, with your fingertips, press it into a 4-inch round. Repeat with the remaining dough, shaping 4 rounds each on 2 baking sheets and spacing the pizzas about 2 inches apart. If the dough keeps shrinking back as you shape it, cover with plastic wrap and let stand at room temperature for 15 minutes before proceeding.

2. Spread 1 tablespoon of pizza sauce over each round, leaving a ½-inch border all around. Sprinkle the cheese evenly over the sauce.

3. Bake for 10 to 12 minutes, or until the edges of the crusts are golden brown. Let the pizzettes cool slightly before cutting and serving.

VARIATIONS

Try different toppings for the pizzettes, whatever your kids crave. Before baking, top the mozzarella with Parmesan or Pecorino cheese, dried oregano or crushed red pepper, cooked sausage, chicken or hamburger meat, pepperoni, red onions or green bell peppers, or (for the adults) mushrooms, olives, and anchovies.

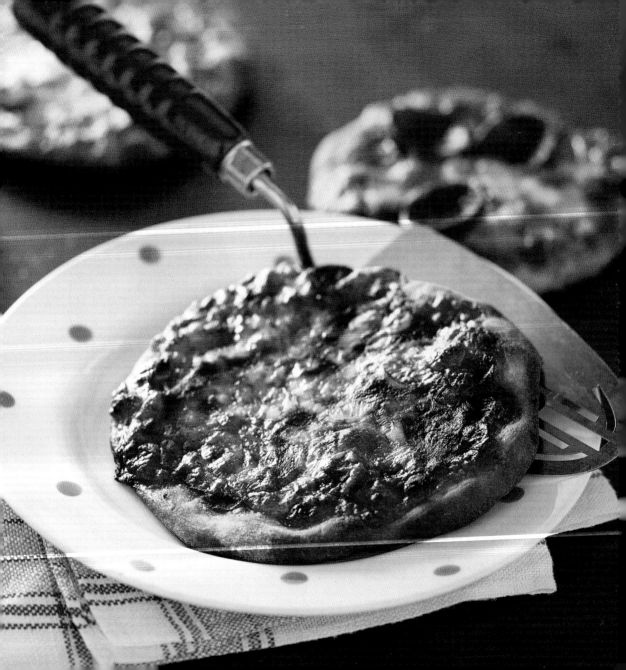

Honey-Glazed
Chicken Wings

*Chicken wings are just the right size for kids' little fingers. These are flavored with
a mild, slightly sweet marinade that turns them a glistening golden brown as they bake.*

SERVES 8

12 meaty chicken wings (about 2½ pounds)

½ cup honey

½ cup soy sauce

6 tablespoons peanut or vegetable oil

3 garlic cloves, smashed

½ teaspoon ground ginger

1. Cut the tips off the chicken wings and cut each wing into 2 pieces.

2. In a small bowl, combine the honey, soy sauce, oil, garlic, and ginger, mixing well. Put
the chicken in a shallow glass baking dish or bowl and add the marinade, turning to coat.
Cover and refrigerate for 2 to 8 hours, turning occasionally.

3. Preheat the oven to 325°F. Line 1 large or 2 smaller baking sheets with foil.

4. Remove the wings from the marinade, reserving the marinade, and arrange them in a
single layer on the prepared baking sheet(s). Bake for 20 minutes. Turn the wings over,
brush with the marinade, and bake for 20 minutes longer. Turn the wings over, brush with
the marinade, and bake for about 10 minutes longer, until cooked through and golden
brown. Let cool slightly and serve.

Itty-Bitty Barbecued
Beef Burritos

These adorable burritos look like ice cream cones wrapped in shiny foil, and they're easy for kids to manage without fancy fork-work. Have plenty of paper napkins!

SERVES 8

½ pound ground beef

½ cup bottled barbecue sauce

¾ cup grated Cheddar cheese (about 3 ounces)

Four 7-inch flour tortillas

Sixteen 3-inch squares aluminum foil

1. Preheat the oven to 350°F.

2. In a large skillet, cook the beef over medium-high heat, stirring frequently, until cooked through and no longer pink, about 5 minutes. Tilt the pan and spoon off any excess liquid. Stir in the barbecue sauce and gradually add the cheese, stirring until it begins to melt. Remove from the heat.

3. Cut each tortilla into 4 wedges. Spoon about 1½ tablespoons of the filling onto each tortilla triangle, mounding it in a smaller triangular shape. Fold the straight sides of each triangle over the filling, making a cone, and wrap a square of foil around each cone so it holds its shape. Place the burritos, seam side up, on a large baking sheet.

4. Bake the burritos for 3 to 5 minutes, until just heated through. Arrange the burritos on a serving platter, spoon any loose filling back into the tortillas, and serve warm.

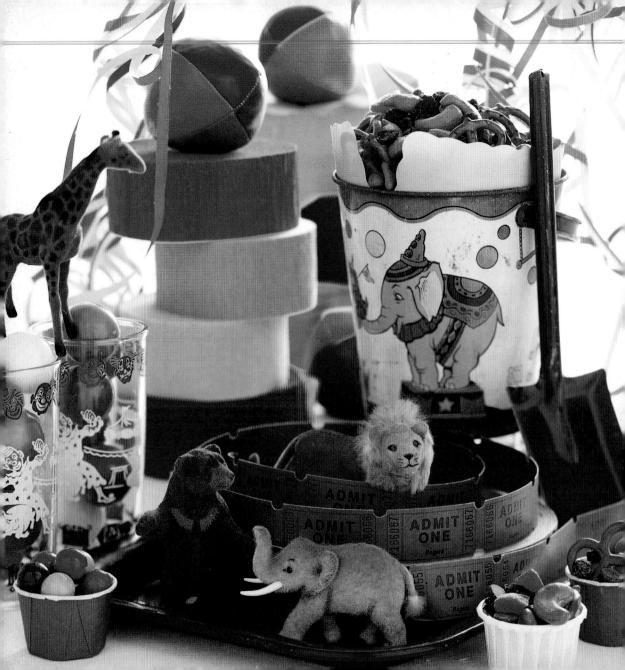

Parties for Kids

From baby's first birthday right through grade school, youngsters love parties, deserve parties, and will even do their homework for parties. Don't wait for a birthday or holiday to toss a party for your kids—they'll enjoy one anytime.

Feature Entertainment

Let there be noise: A quiet party is a snore. Plan music ahead of time to fill rooms, a porch, even a garden.

For older children, a twilight party can feature a spooky video; surprise them with your own sound effects.

Everybody loves riding a pony and feeding hay to the gentle creature. Can't find a pony? Rent a pig!

DECORATE Whether it's a circus party or a school's-out party, decorate with lots of crepe paper streamers and balloons. Rolls of carnival-ride tickets bring order to games like Pin the Tail on the Donkey.

PERSONALIZE PARTY HATS "I'll do it if you'll do it" is the rule, and once everyone gets into the spirit, they'll really enjoy the silly fun of party hats. Paint each guest's name on the front and add silver stars, lace ruffles, any kind of decoration you can think of. Don't forget to make a hat for yourself.

GATHER UP PAILS Line painted summer beach pails or tin buckets with paper and fill each with Party Trail Mix (page 48), brightly colored candies, or fresh cherries. Have small shovels tucked in the pails for serving.

CREATE PARTY FAVORS To help ease the letdown when the party's over, give departing guests favors. If you've had a circus party, use a menagerie of plastic animals; guests at a fairy party could receive star-topped wands. When in doubt, turn to some of the classics: Slinkys, jacks, Frisbees, or rubber balls.

Party *Trail Mix*

Making your own trail mix means you can "customize" it (and it's much less expensive than the packaged products at the market). If you include chocolate chips and pretzels or miniature marshmallows and yogurt-covered raisins, trail mix is enticing enough to take the place of candy cups and other high-sugar foods kids so often ask for at party-time. Serve the mix in muffin cup liners, or wrap quantities in small cellophane bags and tie them with colorful ribbons.

SERVES 8 • MAKES ABOUT 3 CUPS

¾ cup peanuts or other nuts

½ cup mini pretzels or 1-inch pieces small pretzels

½ cup semisweet chocolate chips

¼ cup dried cranberries or cherries

¼ cup Goldfish crackers

¼ cup diced dried pineapple or apricots

¼ cup raisins

¼ cup salted sunflower kernels

In a large bowl, combine all the ingredients and toss to mix well. The trail mix will keep in an airtight container at room temperature for at least 2 weeks.

Chocolate-Frosted *Cupcakes*

*No party is a party without dozens of cupcakes with thickly swirled frosting.
Set up a decorating bar: Stock it with sprinkles, chopped nuts, miniature chocolate
chips, miniature marshmallows, and small candies.*

MAKES 14 CUPCAKES

CUPCAKES

1½ cups all-purpose flour

1½ teaspoons baking powder

¼ teaspoon salt

6 tablespoons (¾ stick) unsalted butter, at room temperature

1 cup granulated sugar

2 large eggs

1 large egg yolk

1 teaspoon vanilla extract

¾ cup milk

CHOCOLATE FROSTING

6 tablespoons (¾ stick) unsalted butter, at room temperature

2 cups confectioners' sugar

3 to 4 tablespoons milk

1 teaspoon vanilla extract

3 ounces milk chocolate, melted

Sprinkles, for garnish

1. Make the cupcakes: Preheat the oven to 350°F. Line 14 muffin cups with foil or paper liners. If you have only one 12-cup muffin tin, place 2 foil muffin liners on a baking sheet and bake the extra batter in them.

2. In a medium bowl, whisk together the flour, baking powder, and salt.

3. In a large bowl, beat the butter and granulated sugar with an electric mixer at medium speed until light and fluffy. Add the eggs and egg yolk 1 at a time, beating well after each

(continued on next page)

addition. Beat in the vanilla. On low speed, beat in the flour mixture alternating with the milk, starting and ending with the flour mixture. Spoon the batter into the prepared muffin cups, filling each about two-thirds full.

4. Bake the cupcakes for 18 to 20 minutes, or until a toothpick inserted into the center comes out clean. Let the cupcakes cool completely in the pan on a wire rack.

5. Make the milk chocolate frosting: In a medium bowl, beat the butter with an electric mixer at medium speed until smooth and creamy, about 1 minute. Beat in 1 cup of the confectioners' sugar, then beat in 3 tablespoons of the milk. Beat in the vanilla, melted chocolate, and the remaining 1 cup confectioners' sugar. Beat for 1 to 2 minutes, or until the frosting is spreadable, adding up to 1 tablespoon more milk if necessary. Ice the cupcakes generously with the frosting and add sprinkles to each.

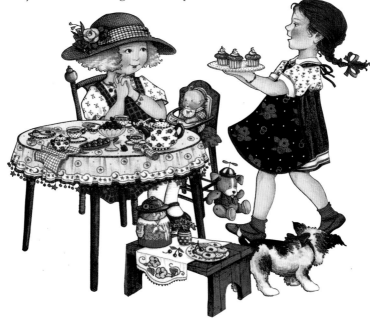

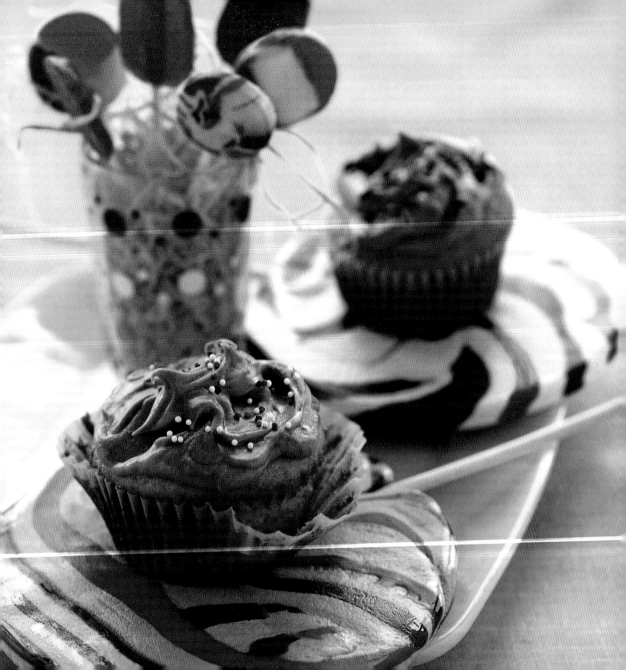

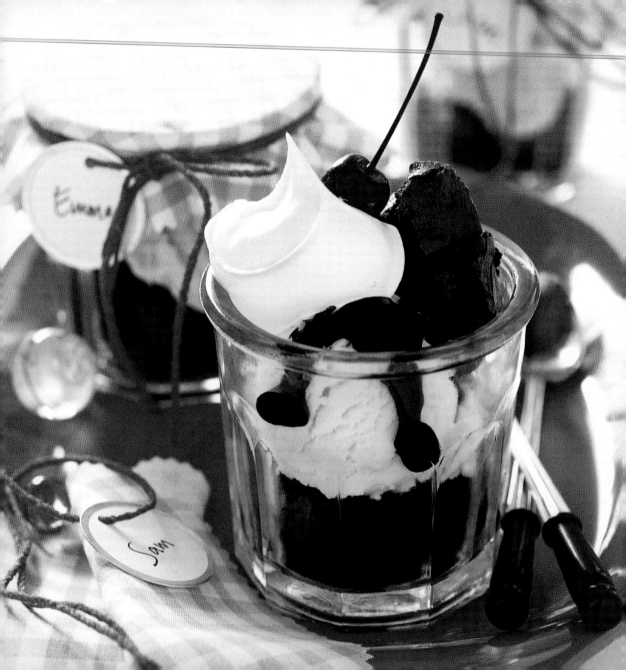

Fudgy
Brownie Sundaes

Now here's an idea: Forget about cookies, candies, or cake of any kind. Serve up luscious brownie sundaes—just one of these babies will do the job for each of your youngsters.

SERVES 8

½ recipe Fudgy Brownie Squares (p. 24), baked and cooled but not cut

FUDGE SAUCE

½ cup heavy cream

3 tablespoons unsalted butter

½ cup granulated sugar

3 tablespoons dark brown sugar

Pinch of salt

½ cup Dutch-processed cocoa powder

½ teaspoon vanilla extract

1 quart vanilla ice cream

Sweetened whipped cream

Maraschino cherries, for garnish

1. Cut the brownies into 9 squares; you'll need only 8, so the extra is the baker's bonus. Cut each square in half. Cover and set aside.

2. Make the fudge sauce: In a small heavy saucepan, combine the cream, butter, both the granulated and dark brown sugar, and salt. Bring just to a simmer over medium heat, stirring to dissolve the sugar. Reduce the heat to medium-low and simmer, stirring occasionally, for 2 minutes. Reduce the heat to low, add the cocoa, and whisk until smooth. Remove from the heat and stir in the vanilla. Let cool slightly.

3. Place a piece of brownie in each bowl and top with a scoop of ice cream. Spoon some sauce over each and garnish with a dollop of whipped cream, another piece brownie and a cherry. Serve immediately.

Peanut Butter Bars

We doubt you'll hear any complaints about these chewy, chewy, chewy peanut butter bars, because they are loaded with chocolate chips. Conveniently, they're just the right size to tuck into a pocket, easing the post-party blues on the ride home.

MAKES 2 DOZEN BARS

1¼ cups all-purpose flour

½ teaspoon baking soda

¼ teaspoon salt

½ cup (1 stick) unsalted butter, at room temperature

1 cup granulated sugar

¼ cup packed light brown sugar

¾ cup crunchy peanut butter

2 large eggs

1 teaspoon vanilla extract

1½ cups mini semisweet chocolate chips

1. Preheat the oven to 350°F. Grease a 9- by 13-inch baking pan.

2. In a medium bowl, whisk together the flour, baking soda, and salt.

3. In a large bowl, beat the butter and both sugars with an electric mixer at medium speed until smooth and creamy. Beat in the peanut butter. Add the eggs 1 at a time, beating well after each addition. Beat in the vanilla. On low speed, beat in the flour mixture in 2 additions (the batter will be stiff). Stir in the chocolate chips. Pour the batter into the prepared pan, spreading it evenly with a rubber spatula or wooden spoon.

4. Bake the bars for 25 to 28 minutes, or until a toothpick inserted in the center comes out with just a few moist crumbs clinging to it. Let cool completely on a wire rack. With a large, sharp heavy knife, cut into 24 bars.

Summer Sunrise

Children will love this colorful orange and red drink; serve it in clear plastic glasses, so they can see the "sunrise." Grenadine is a sweet red syrup made from pomegranate juice; it's sold in supermarkets and, of course, it's non-alcoholic.

SERVES 8

Ice cubes

1 quart orange juice

½ cup grenadine

8 orange wedges, for serving

Fill 8 squat glasses with ice and add ½ cup of the orange juice to each one. Add 1 tablespoon of grenadine to each glass, pouring it around the edge so it runs down the inside of the glass. Serve, garnishing each drink with an orange wedge.

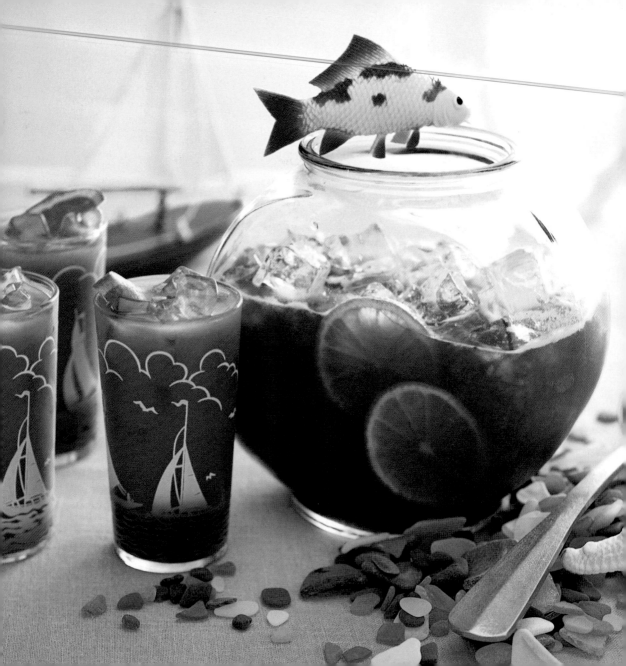

Raspberry-Pineapple
Fruit Punch

This slightly exotic punch gets its beautiful color and delightful taste from raspberries. The punch can be made, through step two, up to four hours ahead of time; just keep it refrigerated.

SERVES 8

One 10-ounce package frozen raspberries in syrup, thawed

4 cups pineapple juice, chilled

One 6-ounce can frozen limeade or lemonade concentrate, thawed

One 16-ounce bottle 7-Up, chilled

Ice cubes

Lime or lemon slices, for garnish

1. In a food processor, process the raspberries to a smooth puree. Strain through a fine sieve, pressing with the back of a spoon to extract as much liquid as possible; discard the solids.

2. In a large pitcher or other container, combine the pineapple juice, limeade concentrate, and raspberry puree, stirring until well blended.

3. Just before serving, add the 7-Up to the pineapple mixture, stirring gently to combine. Serve in a punch bowl, or fill 8 tall glasses with ice and pour the punch into the glasses. Garnish with lime slices and serve.

Summer Sunrise; Raspberry-Pineapple Punch

resh corn: if we had to live on just one food, **corn would be our first choice**. Make it salty, make it sweet, make it the reason for **a party of its own**—your guests will love you.

Roasted Corn

Even easier than boiling corn is roasting it. Cooking the corn in the husks gives the kernels a sweet, slightly nutty taste.

SERVES 8

16 ears corn, in husks
Butter, for serving

Salt and freshly ground pepper, for serving

1. Position a rack in the center of the oven and preheat the oven to 450°F.

2. Snap off any long stalks from the corn. Peel back the husk from each ear, without detaching it, and remove the corn silk. Rewrap the husks and twist the tops slightly to close them.

3. Place the corn directly on the oven rack and roast for 8 to 10 minutes, until the edges of the husks are beginning to brown slightly.

4. Let the corn cool for about 1 minute, then place the ears on a platter and serve. Put one or two large bowls on the table for the husks and allow diners to remove the husks from their own ears. Pass the butter with the salt and pepper.

Spicy *Popcorn*

Chili powder and a touch of ground red pepper give this popcorn an unusual taste. Make double the recipe if you like; if necessary, keep the first batch warm on a baking sheet in a 200°F oven while you pop the second batch, then toss all the popcorn with the flavored butter. Use an air popper or pop the corn the old-fashioned way, in a large heavy saucepan, with one tablespoon vegetable oil per quarter cup corn kernels, or as directed on the label.

MAKES 8 CUPS

3½ tablespoons unsalted butter

½ to ¾ teaspoon chili powder, to taste

¼ teaspoon salt, or to taste

Pinch of ground red pepper

8 cups just-popped popcorn

1. In a small skillet, melt the butter over low heat. Add the chili powder, salt, and ground red pepper and heat, stirring, until fragrant, 30 seconds to 1 minute. Immediately remove the pan from the heat.

2. In a large bowl, toss the popcorn and butter, coating the popcorn evenly. Season with additional salt if necessary and serve immediately.

Fresh *Corn Fritters*

*Golden brown fritters studded with fresh sweet corn kernels, piping hot
from a cast-iron skillet on the stove in a farmhouse kitchen: This is comfort food
at its all-American best!*

½ cup all-purpose flour

½ teaspoon baking powder

¾ teaspoon salt

⅛ teaspoon freshly ground pepper

1 medium egg, lightly beaten

1 tablespoon unsalted butter, melted
and warm

6 tablespoons milk

2 cups fresh corn kernels (about 4 ears)

2 tablespoons diced red bell pepper

1½ tablespoons minced fresh chives

Vegetable oil, for frying

1. In a large bowl, combine the flour, baking powder, and salt and pepper, stirring until well blended. Add the egg, melted butter, and milk, stirring until completely combined. Stir in the corn, bell pepper, and chives.

2. In a large heavy skillet, heat ¼ inch of oil over medium-high heat until very hot but not smoking. Drop the batter by generous teaspoonfuls into the hot oil, without crowding, flattening each fritter slightly with the back of the spoon. Cook until golden brown on the bottom, about 2 minutes. With a spatula, carefully turn the fritters over and cook until golden brown on the second side, about 2 minutes longer. Transfer to paper towels to drain, and repeat with the remaining batter, adding more oil to the pan as necessary; be sure to heat the oil until hot before adding each batch of fritters. Serve the fritters warm. If necessary, they can be kept warm on a baking sheet in a 200°F oven for up to 20 minutes.

Spicy Popcorn; Fresh Corn Fritters; Roasted Corn

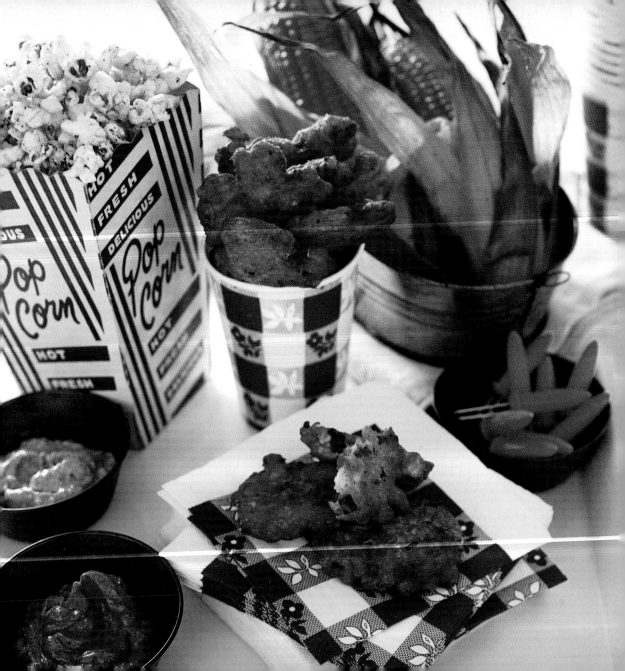

Cheddar Cheese
Corn Bread

*This corn bread is most delicious served warm, but you can do much of
the preparation ahead of time: Combine the dry ingredients, cover, and set aside.
Combine the grated cheese, corn kernels, jalapeño, and herbs, cover,
and refrigerate. Then just melt the butter, mix up the batter, and bake.*

SERVES 8

1 cup cornmeal

½ cup all-purpose flour

1 teaspoon baking powder

½ teaspoon baking soda

1¼ teaspoons salt

2 large eggs, lightly beaten

2 tablespoons unsalted butter, melted and warm

1¼ cups buttermilk

1¾ cups fresh corn kernels (about 3 ears)

1¼ cups grated sharp Cheddar cheese

¼ cup minced fresh cilantro or basil

1 jalapeño pepper, finely minced (optional)

1. Preheat the oven to 425°F. Generously butter an 8-inch square baking pan.

2. In a large bowl, stir together the cornmeal, flour, baking powder, baking soda, and salt. Stir in the eggs, melted butter, and buttermilk, mixing well. Stir in the corn, Cheddar, cilantro, and jalapeño, if using. Pour the batter into the prepared pan.

3. Bake for 25 to 30 minutes, or until the top is lightly browned and a toothpick inserted in the center comes out clean. Let the corn bread cool slightly on a wire rack, then cut into squares and serve warm.

Caramel Corn

If you've only had store-bought caramel corn, you'll be amazed at how good homemade can be—and it's easy, too. Dried caramel is tough to remove from pans and utensils; soak the cooking equipment in hot water for easy cleanup.

MAKES ABOUT 12 CUPS

12 cups just-popped popcorn

½ cup (1 stick) unsalted butter

1 cup packed light brown sugar

¼ cup light corn syrup

¼ teaspoon salt

¼ teaspoon baking soda

½ teaspoon vanilla extract

1. Preheat the oven to 300°F. Butter a large rimmed baking sheet, preferably nonstick, and spread the popcorn out on it.

2. In a large heavy saucepan, combine the butter, brown sugar, corn syrup, and salt. Bring to a boil over medium heat, stirring until the sugar is dissolved. Boil, without stirring, for 5 minutes. Remove from the heat and immediately stir in the baking soda and vanilla.

3. Pour the caramel mixture over the popcorn, stirring and tossing with 2 wooden spoons (be careful, the caramel will be very hot) until the popcorn is well coated. The popcorn need not be completely coated at this point.

4. Bake for 10 minutes, stir well to distribute the melted caramel, and bake for 5 minutes longer. Stir again and bake for 5 minutes. If some of the popcorn is still uncoated, stir well to mix and bake for another 5 minutes. Set the pan on a rack and let cool completely, then break any large clusters into smaller pieces. The caramel corn will keep for at least 1 week in an airtight container at room temperature.

FOOLS RUSH IN

The Impromptu Party

Spicy Olives

Parmesan Pecans

Radish Canapés

Spicy Cheese Coins

Parmesan-Stuffed Mushrooms

Crostini with Garlicky Beans

Roasted Red Pepper Frittata

Tomato & Feta in Pita Pockets

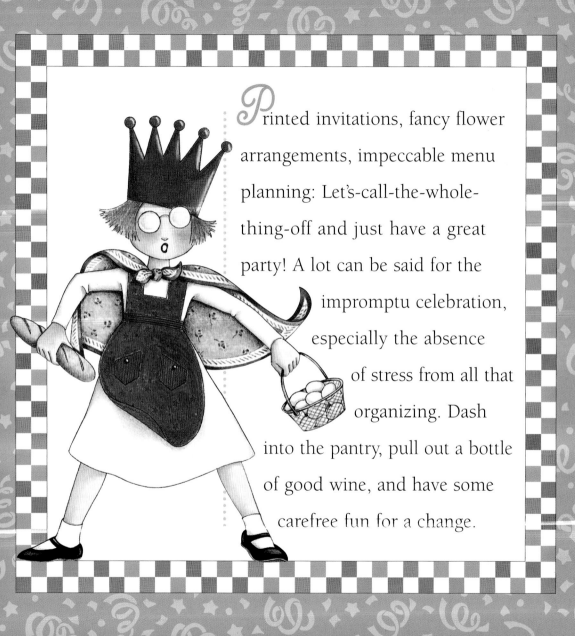

\mathcal{P}rinted invitations, fancy flower arrangements, impeccable menu planning: Let's-call-the-whole-thing-off and just have a great party! A lot can be said for the impromptu celebration, especially the absence of stress from all that organizing. Dash into the pantry, pull out a bottle of good wine, and have some carefree fun for a change.

Spicy Olives

Choose your favorite olives—Kalamata, Sicilian, Gaeta—or a mix of several types.
Even olives from the jar are tasty prepared this way.

SERVES 8 · MAKES 2 CUPS

> 2 cups olives or one 10-ounce jar Spanish olives, drained
>
> 3 tablespoons olive oil
>
> 4 garlic cloves, smashed into pieces
>
> 1 teaspoon red pepper flakes

1. Put the olives in a small serving bowl or other container. In a small skillet, combine the oil, garlic, and red pepper flakes and heat over low heat, swirling the pan or stirring frequently, until the mixture is fragrant, about 3 minutes; do not let the garlic brown.

2. Pour the hot oil mixture over the olives, stirring to coat evenly with the pepper flakes. Cover and refrigerate for at least 1 hour before serving. The olives can be prepared up to 3 days in advance; remove them from the refrigerator about 15 minutes before serving.

Spicy Olives; Parmesan Pecans

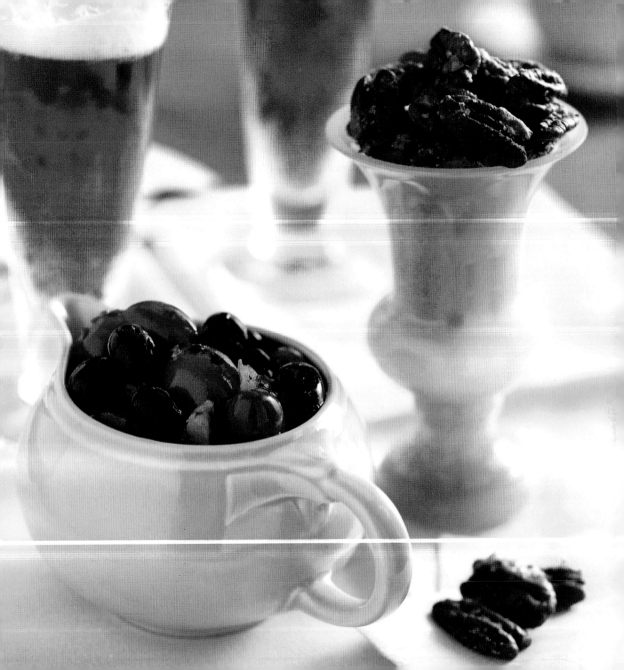

Parmesan Pecans

Buttery pecans are coated with grated fresh Parmesan cheese,
then baked until they're fragrant and golden, and completely irresistible.

SERVES 8 · MAKES 2 CUPS

2 tablespoons unsalted butter

2 cups pecans (about 10 ounces)

Salt, to taste

6 tablespoons freshly grated Parmesan cheese

1. Preheat the oven to 250°F. Line a large baking sheet with foil, or use a nonstick baking sheet.

2. Melt the butter in a small saucepan. Put the pecans in a large bowl and pour the butter over them, tossing with a wooden spoon to coat. Season to taste with salt, then add the Parmesan about 2 tablespoons at a time, tossing and stirring to mix well.

3. Spread the nuts on the prepared baking sheet, separating any clumps. Bake for 25 to 30 minutes, stirring 3 or 4 times, until the nuts are slightly golden. Let cool slightly, then taste and sprinkle with additional salt if needed. Let cool completely before serving. The nuts can be stored in an airtight container at room temperature for up to 3 days.

Radish Canapés

Peppery red radishes served with sweet butter, sea salt, and fresh bread are
a favorite French snack. Here we have made open-faced radish canapés, but you can
present the individual components as the French do, for your guests to nibble on
as they like: Mound one or two bunches of radishes, cleaned but still sporting their small
green leaves, in a glass bowl and set out small crocks or ramekins of softened butter
and salt, and a basket of baguette slices or thinly sliced brown bread.

SERVES 8 • MAKES 24 CANAPÉS

I small bunch radishes, trimmed

3 tablespoons unsalted butter, at room
temperature

Twenty-four ¼-inch-thick slices baguette

Sea salt, for sprinkling

Snipped chives, for garnish

1. Slice the radishes as thin as possible—a mandoline is the best tool for this, but a food processor or sharp knife will do the trick.

2. Spread the butter evenly over each slice of bread. Arrange 5 or so (depending on their size) radish slices on each slice of bread, overlapping them slightly.

3. Arrange the canapés on a serving platter. Sprinkle with salt and chives, and serve.

Canapés

Canapés are the perfect tidbit to accompany cocktails: A small slice of bread simply adorned can be easily slipped into the mouth. They can be served hundreds of different ways, from simple to very fancy, making them a necessity for all your entertaining. Put out a variety of toppings in small bowls along with a tray of sliced bread and crackers, then watch your guests have fun mixing and matching.

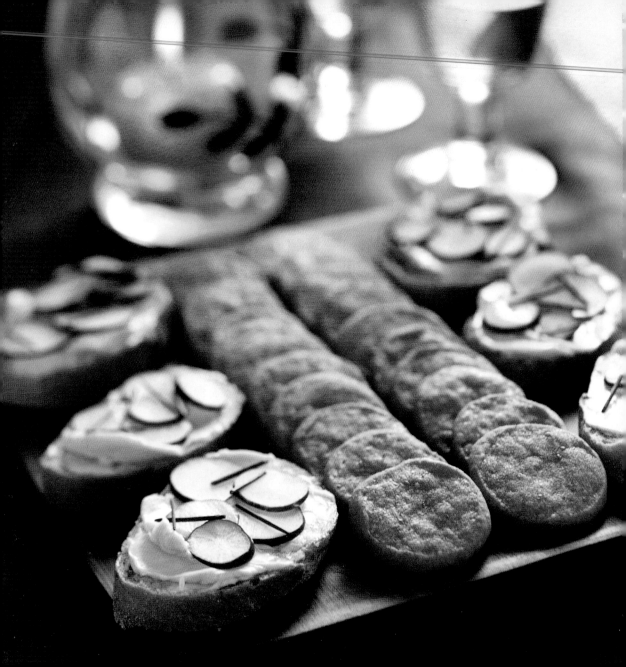

Spicy *Cheese Coins*

*Keep a roll or two of this easy to make slice-and-bake dough in the freezer,
ready for unexpected guests. The crackers have a delicate texture and a definite zip—
far better than the expensive versions found at gourmet markets. We love their spiciness,
but of course you can leave out the cayenne if you prefer plain Cheddar coins.*

MAKES 64 COINS

½ cup (1 stick) unsalted butter, at room temperature

4 ounces sharp Cheddar cheese, finely grated

¼ teaspoon salt

¼ teaspoon ground red pepper

1 cup plus 2 tablespoons all-purpose flour

1. In a large bowl, preferably the bowl of a heavy-duty mixer, beat the butter until creamy, about 30 seconds. Add the Cheddar and mix until well blended. Beat in the salt and cayenne. Add half the flour and beat until well blended, then beat in the remaining flour. The dough will be stiff; if necessary, turn it out onto a lightly floured work surface and knead gently until smooth.

2. Divide the dough in half. Roll each half under your palms into an 8-inch cylinder. Wrap in plastic wrap and freeze until firm, at least 2 hours.

3. Preheat the oven to 350°F. Grease and flour 2 baking sheets.

4. With a sharp knife, cut each cylinder of dough into ¼-inch-thick slices and arrange about 1 inch apart on the prepared baking sheets. Bake for 12 to 14 minutes, until the crackers are set and just barely golden around the edges.

5. Transfer the crackers to wire racks and let cool completely.

Radish Canapés; Spicy Cheese Coins

Parmesan
Stuffed Mushrooms

*This delectable filling is also delicious on crackers or small toasts—you may
even find yourself snacking on it straight from the fridge. If you don't have mozzarella
on hand, substitute Colby, Monterey Jack, or a mild Cheddar.*

SERVES 8

⅔ cup mayonnaise

⅔ cup freshly grated Parmesan cheese

½ cup grated mozzarella cheese

⅔ cup minced red onion

Freshly ground pepper

3 tablespoons minced fresh flat-leaf parsley,
plus leaves for garnish

I pound small to medium
white mushrooms

1. In a medium bowl, combine the mayonnaise, cheeses, and onion, mixing well. Season to
taste with pepper and stir in the parsley. Cover and refrigerate until ready to use.

2. Preheat the broiler. Remove the mushroom stems and wipe the caps clean. Spoon a generous teaspoonful of the filling into each mushroom cap, mounding it slightly. Arrange the
mushrooms, filling side up, on the broiler pan (you may have to cook the mushrooms in 2
batches). Broil about 5 inches from the heat source for about 5 minutes, until the mushrooms are hot and the filling is lightly golden brown. Let cool for just 1 minute. Garnish
each mushroom with a parsley leaf, transfer to a platter, and serve.

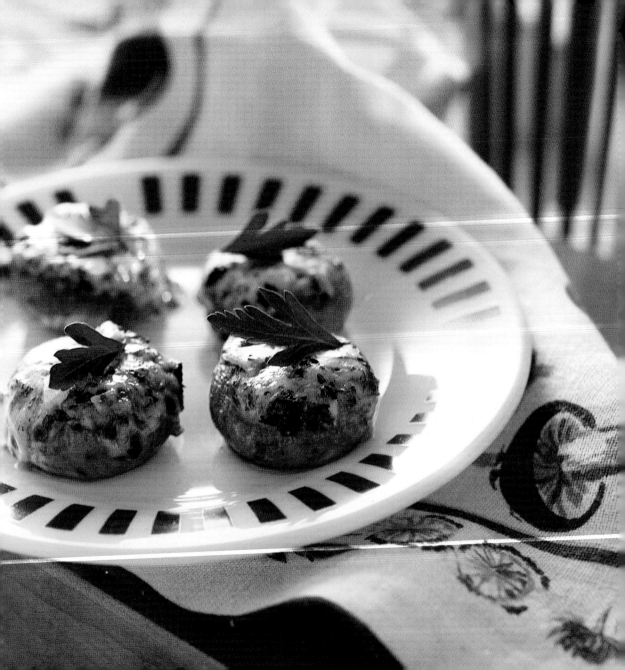

Crostini with
Garlicky Beans

Crostini are Italian canapés, small rounds of grilled bread topped with savory ingredients. The puree for this topping is easily made with canned white beans and if your baguette happens to be a day old, it will make no difference.

SERVES 8 · MAKES 24 HORS D'OEUVRES

Twenty-four ½-inch-thick slices baguette

About ½ cup olive oil, preferably extra virgin, plus extra for drizzling

4 garlic cloves, minced

Two 15-ounce cans cannellini beans, drained and rinsed

3 tablespoons minced fresh flat-leaf parsley

Salt and freshly ground pepper, to taste

1. Preheat the oven to 400°F. Arrange the baguette slices on a large baking sheet and brush both sides with oil, using about 2 tablespoons in all. Bake for 6 to 7 minutes, or until the toasts are golden brown on the bottom. Turn the toasts and bake for about 5 minutes longer, until golden brown on the second side. Let cool.

2. In a large deep skillet, combine the remaining 6 tablespoons oil and the garlic. Cook over medium-low heat, stirring occasionally, until the garlic is softened, 1 to 2 minutes. Add the beans and cook, stirring, until heated through. With a wooden spoon, mash the beans to a coarse puree, incorporating the oil. There should still be some noticeable chunks of beans. Stir in 1 tablespoon of parsley; season with salt and pepper. Remove the pan from the heat.

3. Arrange the toasts on a serving platter and spoon a generous tablespoon of the puree onto each. Sprinkle with the remaining 2 tablespoons parsley, drizzle a few drops of olive oil over each crostini, and serve warm.

Roasted Red
Pepper Frittata

*If you've got eggs and a jar of roasted peppers, you can whip up this easy dish
in minutes. It's good warm, at room temperature, or cold, so you can serve it anytime.*

SERVES 8

2 tablespoons unsalted butter

1 large onion, finely chopped

1 garlic clove, minced

2 small roasted red bell peppers, cut
lengthwise into ⅛-inch-thick strips

Salt and freshly ground pepper, to taste

6 large eggs

½ cup freshly grated Parmesan cheese

1. In a broiler-proof nonstick 10-inch skillet, melt the butter over medium heat. Add the onion and cook, stirring frequently, for 5 to 7 minutes, or until soft. Add the garlic and cook, stirring, until fragrant. Stir in the roasted peppers and season with salt and pepper.

2. Meanwhile, in a medium bowl, whisk the eggs until well blended. Whisk in 6 tablespoons of Parmesan and season generously with salt and pepper.

3. Pour the egg mixture over the onions and peppers and stir to mix well, then spread the onions and peppers evenly in the pan. Immediately reduce the heat to low and cook for 15 to 18 minutes, or until the frittata is set but still slightly runny in the center.

4. Meanwhile, heat the broiler. Sprinkle the remaining 2 tablespoons Parmesan over the frittata, place under the broiler, and broil just until the frittata is set, about 1 minute.

5. Run a spatula around the edges of the frittata and slide it onto a serving plate. Serve cut into wedges or bite-size pieces.

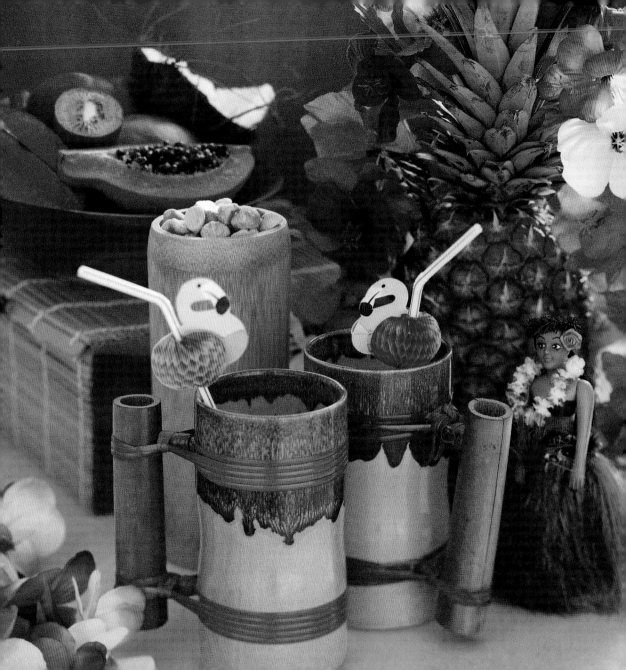

Impromptu Parties

"Company's here!" No time to dress up, no time to clean up, and no plans to mess up! Like an unexpected laugh, a spontaneous get-together can help us all live longer.

Feature Entertainment

Break out a movie: anything with Cary Grant or W. C. Fields; Fred and Ginger; Jim Carrey or Spinal Tap.

Put on the soundtrack to a Broadway musical and sing along.

Remember that nothing's too corny for the impromptu gathering: board games, cards, even charades.

BOW TO THE INEVITABLE You've got guests—be flattered you have friends who know you will welcome their sudden visit. Here are folks who don't expect a lavish display of fine food and drink, only your charming company.

BUT BE PREPARED Keeping a few party staples in a hamper in the pantry will ensure that you have the makings of a successful little party, any time, any day. Having funky glasses and kitchy decorations handy wouldn't hurt, either.

IMPROVISE LIKE CRAZY Maybe you wouldn't ordinarily serve guests peanut butter sandwiches and hot chocolate, but we all enjoy these simple foods. Just have eggs? Make a frittata. Nothing but bread and chocolate in the cupboard? Make toasted chocolate sandwiches. Just have fun.

FORGET THE HOUSE Yes, turn a blind eye to the dust on the dining room sideboard. Ignore the smudges on the powder room mirror. A quick check for hand soap and other necessities is all that's needed.

Tomato & Feta
in Pita Pockets

A colorful, tangy salad in pitas—these take very little time to make.
Substitute mozzarella or a mild Cheddar, cut into cubes, if you don't have feta cheese.

SERVES 4

LEMON DRESSING

3 tablespoons olive oil

I tablespoon fresh lemon juice

⅛ teaspoon dried oregano (optional)

Salt and freshly ground pepper, to taste

TOMATO SALAD

I cup cherry tomatoes, quartered (about 5 ounces)

3 tablespoons minced red onion or scallions

½ English (seedless) cucumber, quartered lengthwise and cut into ¼-inch-thick slices, or I small regular cucumber, quartered lengthwise, seeded, and cut into ¼-inch-thick slices

4 ounces feta cheese, crumbled

1½ tablespoons chopped fresh flat-leaf parsley

Salt and freshly ground pepper, to taste

4 small romaine lettuce leaves

4 pita breads

1. Make the lemon dressing: In a small jar, combine the oil, lemon juice, oregano, if using, and salt and pepper. Cover tightly and shake until well blended; set aside.

2. Make the tomato salad: In a medium bowl, combine the cherry tomatoes, red onion, cucumber, feta, parsley, and salt and pepper, tossing with a fork until well mixed. Add the dressing and toss to coat. If desired, cover and refrigerate for 30 minutes, or until the salad is slightly chilled.

3. Cut off one third of each pita bread. Place a romaine leaf in each pita pocket. Spoon the tomato salad into the pitas, filling them generously, and serve.

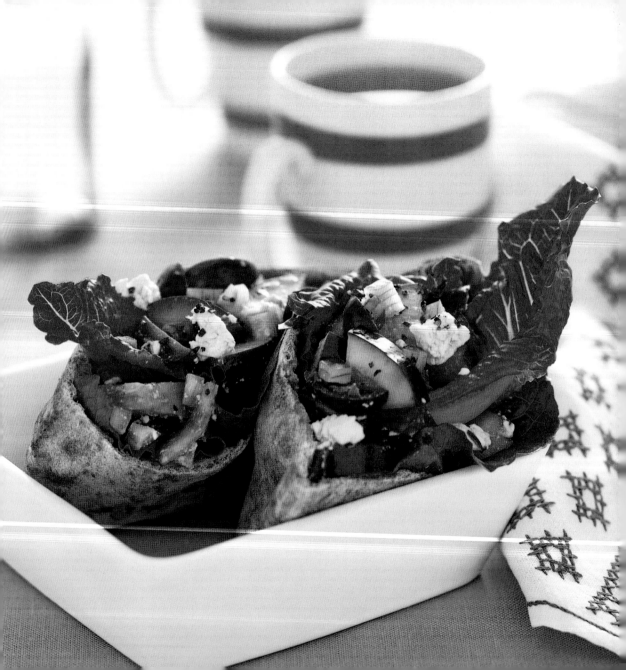

*N*ow, thankfully, shrimp is **plentiful all year round** in the best quality at fish counters in supermarkets. **What a wonderful world**.

Shrimp with Spicy Cocktail Sauce

Homemade cocktail sauce takes only minutes to prepare, but it tastes so much livelier than the bottled version, and you can adjust the heat to your own taste.

SERVES 8

1½ pounds medium shrimp, peeled, tail portion left on, if desired, and deveined

½ cup ketchup

¼ cup prepared horseradish, or to taste

2 teaspoons fresh lemon juice

8 to 10 dashes hot sauce, or to taste

1. Bring a large pot of salted water to a boil. Add the shrimp and cook, stirring occasionally, for 2 to 3 minutes, or just until they turn pink. Immediately drain and rinse under cold water. Drain thoroughly, transfer to a bowl, cover, and refrigerate until chilled, 1 to 2 hours.

2. In a small bowl, combine the ketchup, horseradish, lemon juice, and hot sauce, mixing well. Transfer to a small serving bowl, cover, and refrigerate until chilled.

3. Place the bowl of sauce in the center of a large serving platter. Arrange the shrimp around it and serve immediately.

Sauteed Shrimp
with Garlic Sauce

These shrimp are typical of those in Spanish tapas bars, where a variety of tidbits are always set out to accompany a glass or two of sherry. They are bathed in a fragrant sauce of garlic and red pepper. Serve plenty of crusty bread to mop up the sauce.

SERVES 8

⅔ cup olive oil

4 large garlic cloves, coarsely chopped

2 teaspoons red pepper flakes

1½ pounds medium shrimp, peeled, tail portion left on, if desired, and deveined

Salt, to taste

1 tablespoon finely chopped fresh flat-leaf parsley

Crusty country bread, for serving

1. Divide the oil between two large heavy skillets and add half the garlic and red pepper flakes to each pan. Heat over medium-high heat, stirring frequently, for 1 to 2 minutes, or until the garlic has softened and the oil is very fragrant; do not let the garlic brown.

2. Season the shrimp very generously on both sides with salt and add half the shrimp to each pan. Cook, stirring occasionally and turning the shrimp once or twice, for about 2 minutes, until they are pink and just cooked through. Transfer the shrimp to deep individual plates or a deep platter, spoon the garlicky pan juices over them, and sprinkle with the parsley. Serve immediately, with bread to mop up the sauce.

Grilled Shrimp with Prosciutto

The salty-sweet flavor of prosciutto is a perfect complement to sweet shrimp. A good domestic prosciutto, rather than an expensive imported Italian one, is just fine here. If you prefer, skewer each shrimp individually, then grill. For a lively presentation, halve an orange or grapefruit, place it cut-side-down in a serving bowl, and stand the skewers of shrimp in the fruit. Garnish with fresh rosemary.

SERVES 8

3 tablespoons fresh lemon juice

3 tablespoons olive oil

1 tablespoon finely chopped fresh rosemary or 2 teaspoons crumbled dried

¾ pound medium shrimp, peeled, tail portion left on if desired, and deveined

6 ounces thinly sliced prosciutto

Freshly ground pepper, to taste

1. Combine the lemon juice, oil, and rosemary in a shallow bowl. Add the shrimp, tossing to coat. Cover and refrigerate for 30 minutes, tossing once or twice.

2. Prepare a hot fire in a grill. Soak 10 to 12 wooden skewers in warm water to cover for 15 minutes; drain.

3. Trim the excess fat from the prosciutto and cut the prosciutto into strips about 1 inch by 4 inches. Remove the shrimp from the marinade and season with pepper. Wrap a strip of prosciutto around each shrimp, leaving part of the head and the tail exposed. Thread 3 shrimp crosswise on each skewer, leaving a small space between each.

4. Grill until the shrimp are pink and the prosciutto is beginning to crisp, 2 to 3 minutes per side. Slide the shrimp from the skewers onto a platter and serve.

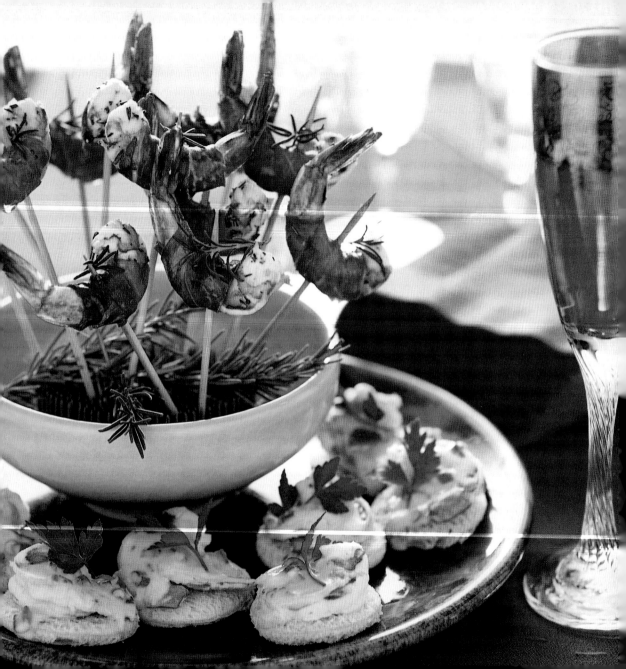

Shrimp Toast
with Blue Cheese

This is hardly the bland shrimp toast you'll find in so many Chinese restaurants.
First the shrimp is poached in a delicate, wine-scented vegetable broth, then it's arranged
on toasted croutons. Just before serving, the shrimp is glazed with a luscious
creamy blue cheese topping. Though the combination of shrimp and blue cheese may
seem a bit startling, the flavors play beautifully off each other and, with the croutons,
create a medley of textures.

SERVES 8

8 cups water

1 cup dry white wine or dry vermouth

1 large carrot, halved lengthwise and then crosswise

1 onion, halved

2 bay leaves

2 teaspoons salt

12 to 15 black peppercorns

1 pound medium shrimp, peeled and deveined

BLUE CHEESE TOPPING

8 ounces Saga Blue or other creamy blue cheese, rind removed, at room temperature

1 tablespoon cream or half-and-half

2 scallions, white and tender green parts, finely minced

18 to 20 slices thin white sandwich bread

2 tablespoons minced fresh flat-leaf parsley, for garnish

1. In a large stainless steel saucepan, combine the water, wine, carrot, onion, bay leaves, salt, and peppercorns and bring to a boil over high heat. Add the shrimp and cook, stirring once or twice, for about 2 minutes, just until opaque throughout. Drain and spread out on a platter to cool, then cover and refrigerate.

2. Make the blue cheese topping: In a small bowl, combine the cheese and cream and beat with a wooden spoon until smooth. Stir in the scallions. Cover and refrigerate.

3. Preheat the oven to 325°F.

4. Using a 2-inch round cutter, cut 2 rounds from each slice of bread, so that you have as many rounds as shrimp. Arrange the rounds on a large baking sheet and bake just until crisp but not colored, 10 to 12 minutes. Set aside.

5. Heat the broiler. With a small sharp knife, split each shrimp in half down the back, but leave them attached at the head. Place 1 shrimp on each toast, fanning out the tail portions, and spoon about 1 teaspoon of the topping onto each one. Broil just until the cheese is beginning to melt, about 1 minute. Arrange the rounds on a platter, sprinkle with the parsley, and serve immediately.

Pickled Shrimp

with Cajun Rémoulade

Pickled shrimp are a Southern specialty—small shrimp are cooked, then marinated in a spiced brine, giving them a unique flavor and texture. They can be served on their own, or with our zesty Cajun version of rémoulade, the French mayonnaise and mustard sauce. Cajun rémoulade can also accompany other chilled seafood, or cold roast beef or pork.

SERVES 8

1½ pounds medium-small shrimp, peeled, tail section left on, if desired, and deveined

2 cups cider vinegar

1 cup water

¼ cup coriander seeds

2 tablespoons mustard seeds

2 to 4 small dried chiles

4 bay leaves

1½ cups olive oil

1 red onion, halved lengthwise and thinly sliced

8 to 12 garlic cloves, smashed

2 lemons, thinly sliced

Salt and freshly ground pepper, to taste

CAJUN RÉMOULADE

1 cup mayonnaise

1 tablespoon capers, drained and coarsely chopped

1 to 2 garlic cloves, minced

1 teaspoon Dijon mustard

¼ teaspoon hot sauce

Ground red pepper, to taste

Few drops of fresh lemon juice (optional)

1½ tablespoons minced fresh flat-leaf parsley

1. Bring a large pot of salted water to a boil. Add the shrimp and cook, stirring several times, for about 2 minutes, or just until they are opaque throughout. Drain and spread out on a baking sheet to cool.

2. Meanwhile, in a stainless steel saucepan, combine the vinegar, water, coriander seeds, mustard seeds, chiles, and bay leaves. Bring the mixture to a boil over high heat. Reduce the heat and simmer gently for 10 minutes. Transfer the mixture to a large bowl and let cool to room temperature.

3. Add the oil, onion, garlic, lemon slices, and salt and pepper to the vinegar mixture. Add the shrimp; stir and toss gently to coat. Transfer the shrimp and brine to a wide-mouthed jar or other deep narrow container. Cover tightly, and refrigerate for 48 hours, turning the jar occasionally to coat all the shrimp in the brine.

4. Make the Cajun rémoulade: In a small bowl, combine the mayonnaise, capers, garlic, mustard, hot sauce, ground red pepper, and lemon juice, if using, and stir until well blended. Stir in the parsley. Cover and refrigerate until ready to serve.

5. To serve, remove the shrimp from the brine, discarding the bay leaves, and arrange them on a deep platter or serving dish. The shrimp look most attractive with the lemon slices and other brine ingredients still clinging to them; the coriander and mustard seeds will have become soft, so there is no need to remove them. Serve with the rémoulade on the side for dipping. If you removed the tail sections from the shrimp, provide toothpicks for spearing.

BLITHE SPIRITS

Cocktail Parties

"Tipsy" Olives

Crudités with Herb Dip

Cheese Puffs

Artichoke & Goat Cheese Dip

Caviar

Ham Biscuits

Chicken Liver Pâté

Creamy Crab Dip

Smoked Salmon Pinwheels

Lemon-Scented Petticoat Tails

Margaritas by the Bucket

Bloody Marys

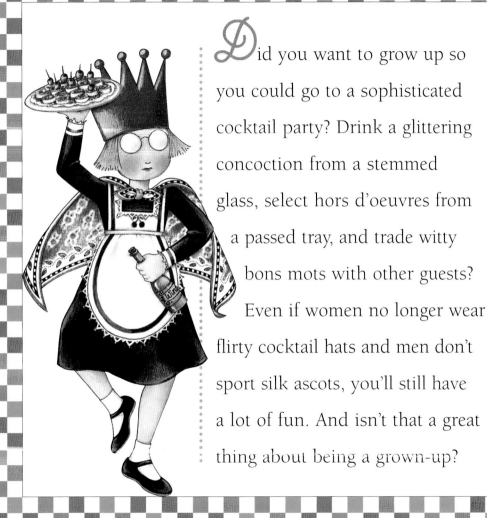

*D*id you want to grow up so you could go to a sophisticated cocktail party? Drink a glittering concoction from a stemmed glass, select hors d'oeuvres from a passed tray, and trade witty bons mots with other guests? Even if women no longer wear flirty cocktail hats and men don't sport silk ascots, you'll still have a lot of fun. And isn't that a great thing about being a grown-up?

"Tipsy" Olives

This is almost a martini in an olive, rather than an olive in a martini.
Buy cracked olives if you can find them. For a spicy version, toss a few dried
chiles into the mix.

SERVES 8 • MAKES 2 CUPS

2 cups medium-to-large Spanish, Greek,
Sicilian, or other brine-cured green olives

1 cup dry white vermouth, or more if needed

10 thin strips lemon zest removed with a
vegetable peeler

1. If the olives are not already cracked, place them, a
few at a time, on a cutting board. Set a heavy saucepan
or skillet on top, and press down gently to crack them.

2. Put about one third of the olives in a small glass jar
or other container and scatter half the strips of lemon zest
over them. Add half the remaining olives and the
remaining zest, then add the remaining olives. Pour
the vermouth over the top—it should just cover
the olives. Cover tightly and refrigerate for at least 2
days and up to 1 week.

3. To serve, drain the olives, reserving the liquid for any
leftover olives. Place the olives in a serving bowl or in
stem glasses. Set out a small bowl for the pits.

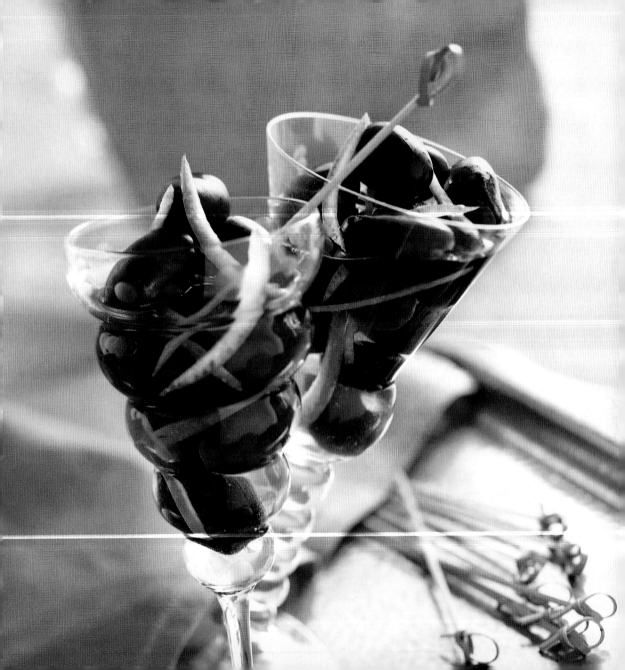

Crudités with *Herb Dip*

Serve this easy dip with a platter of colorful crudités. Choose your favorite vegetables, at least three, and try to contrast textures. The vegetables can be prepared up to a day ahead and refrigerated separately in sealed plastic bags. Vary the herbs in the dip according to your preference; use a greater proportion of more delicate ones such as basil or chervil and less of the pungent ones such as rosemary or marjoram.

SERVES 8

HERB DIP

¾ cup mayonnaise

1 cup packed fresh spinach leaves, tough stems removed

¼ cup packed chopped fresh herbs such as 2 tablespoons basil, 1 tablespoon chives, and 1 tablespoon mixed tarragon, thyme, and marjoram

¾ cup plain low-fat yogurt

Salt and freshly ground pepper, to taste

VEGETABLES

¼ to ½ pound sugar snap peas or ¼ pound snow peas, trimmed and tough strings removed

2 large stalks broccoli, cut into small florets

2 to 3 bell peppers, preferably a mix of red, yellow, and green, cored, seeded, and cut into thick strips

1 pint cherry tomatoes

½ pound carrots, peeled and sliced on the diagonal into ovals

2 to 3 small zucchini, sliced on the diagonal into ovals

1 to 2 bunches radishes, trimmed

1 bunch scallions, trimmed

1. Make the herb dip: Combine the mayonnaise, spinach, and herbs in a blender or small food processor and process until the greens are finely chopped. Transfer to a medium bowl.

2. Add the yogurt to the herb mixture, stirring until smooth. Season with salt and pepper. Cover and refrigerate for at least 1 hour before serving, to allow the flavors to blend.

3. If you are using sugar snap or snow peas, blanch them in a large saucepan of boiling water for 30 seconds to 1 minute, until bright green. Immediately drain in a colander and rinse under cold running water to stop the cooking and preserve the color; drain well. If using broccoli, blanch the florets in a large saucepan of boiling water for 1 to 2 minutes, until bright green; drain and rinse as directed for the peas.

4. Transfer the dip to a small serving bowl and place in the center of a platter or tray. Arrange the crudités around the dip and serve.

Fruit Tips

Don't forget to use fruit on your crudités platter: Clusters of seedless grapes, slices of apple that have been tossed with lemon juice to prevent discoloration, pineapple chunks, and strawberries add a terrific flavor contrast. Fruit is particularly welcome in the summer months, when everyone leans toward lighter fare.

Cheese Puffs

Watch out: Guests will devour these savory puffs as if they were popcorn.
If you do not have three baking sheets, simply pipe some puffs onto a sheet of buttered
and floured foil; after a baking sheet from the first batch has cooled completely,
slide the foil onto it and bake.

MAKES ABOUT 80 PUFFS

1 cup water

½ cup (1 stick) unsalted butter, cut into 8 pieces

½ teaspoon salt

1 cup all-purpose flour

4 large eggs

⅛ teaspoon ground red pepper (optional)

¾ cup finely grated sharp Cheddar cheese (about 3 ounces)

1. Position the racks in the upper and lower thirds of the oven and preheat the oven to 425°F. Butter and flour three large baking sheets.

2. In a medium saucepan, combine the water, butter, and salt. Heat over medium-low heat, stirring, until the butter has melted. Increase the heat to medium and bring just to a boil; immediately remove from the heat.

3. Add the flour all at once and stir with a wooden spoon until a smooth dough forms. Return the pan to medium heat and stir for 2 to 3 minutes, or until the dough dries out slightly and comes away from the sides of a pan. Remove from the heat.

4. Add 1 egg to the dough and beat with a wooden spoon until it is completely incorporated. The dough will separate and appear stringy, but it will come back together as it is beaten. One at a time, beat in the remaining eggs, until each one is completely incorporated. Beat in the ground red pepper, if using, then beat in the cheese until well mixed.

5. Spoon the dough into a large pastry bag fitted with a ½-inch plain tip. Pipe small mounds of dough, slightly less than 1 inch in diameter and about ½ inch high, onto the prepared baking sheets, spacing them about 1½ inches apart.

6. Place 2 baking sheets in the oven and bake the puffs for 15 minutes. Switch the positions of the baking sheets and bake for about 10 minutes longer, until the puffs are light golden brown. Set the baking sheets on wire racks and bake the third sheet of puffs. Serve warm or at room temperature.

Artichoke &
Goat Cheese Dip

*Try this more contemporary version of the traditional warm artichoke dip,
made with fresh goat cheese rather than mayonnaise and served slightly chilled.
Choose a mild, creamy goat cheese so the flavor of the artichokes won't be
overwhelmed. This makes a generous amount; you may want to halve the recipe
if you are serving a number of other hors d'oeuvres.*

SERVES 8

One 14-ounce can artichoke hearts, drained
and rinsed

One 10½- to 11-ounce log Montrachet
or other mild fresh goat cheese, at room
temperature

3 tablespoons light cream, half-and-half, or
milk

1 teaspoon minced fresh tarragon or
½ teaspoon dried

Salt and freshly ground pepper, to taste

Crackers, for serving

1. Gently squeeze the excess liquid from the artichoke hearts. Cut them lengthwise into thin
slivers and transfer to a medium bowl. Add the cheese, cream, and tarragon and blend well
with a large wooden spoon. Season with salt and pepper. Cover and refrigerate for at least
2 hours, and up to 24, to allow the flavors to blend.

2. About 15 minutes before serving, remove the dip from the refrigerator. Serve with the
crackers, and several small knives for spreading.

Caviar

*Caviar is the ultimate luxury, and for good reason. It can be
breathtakingly expensive, but for an intimate gathering, no food is more elegant.*

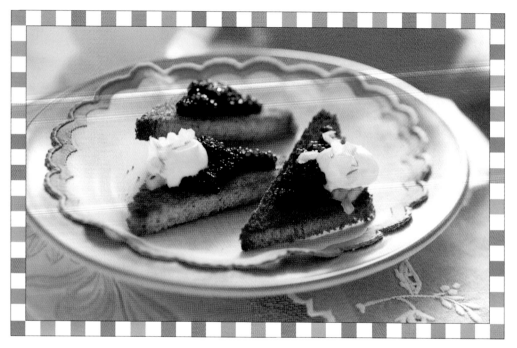

Set out the caviar, either in its tin or in a small glass serving bowl, nestled in a bowl of shaved ice. A silver spoon will affect its taste, so petite mother-of-pearl spoons are traditional. Place toast points in a white napkin-lined basket, and set out little containers of minced onion, finely chopped hard-cooked egg (yolks and whites separate), and crème fraîche or sour cream. Sip Champagne or iced vodka, the classic accompaniments.

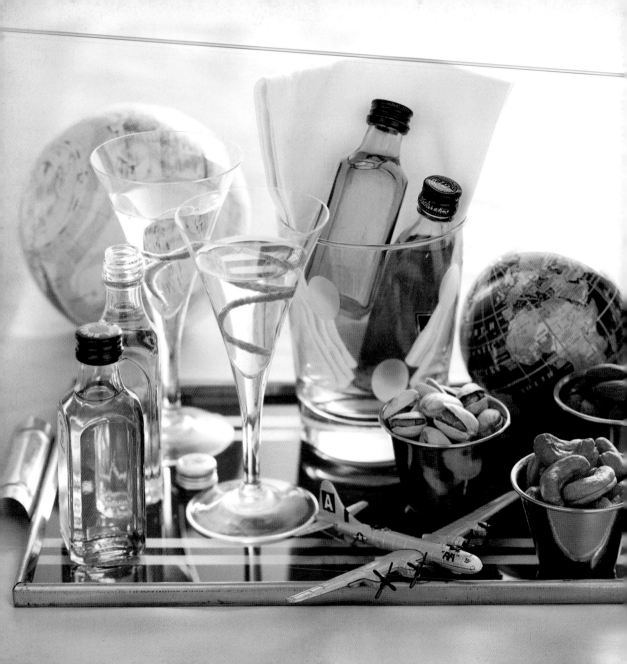

Cocktail Parties

A cocktail party, perhaps just two hours long, is more urbane than lunch but less formal than dinner, and should be treated as such. Sophisticated hors d'oeuvres, intriguing cocktails, scintillating conversation—the glamour is undeniable.

Feature Entertainment

No baby grand piano? Pick up some George Gershwin CDs and let a guest play deejay for the evening.

Set aside a spot for dancing. You're never too young or too old.

Be happy. The best hostess is thrilled to see her guests and is prepared with some provocative (but not controversial) opinions on current events.

KEEP IT SIMPLE An invitation to a cocktail party does not mean dinner, or an evening of entertainment. When you invite guests, mention the specific hours of the party, and that the occasion is drinks only.

BUT MAKE IT SPECIAL Offer at least one specialty drink, such as freshly made margaritas or pitchers of martinis. And leave the jelly glasses in the cupboard; whether you're serving wine or cocktails, give guests their libations in your best stem or highball glasses.

CREATE SOME ATMOSPHERE Break out your good serving trays and accent hors d'oeuvre arrangements with fresh flowers; light candles throughout the room; play elegant background music. Jazz up martinis with lemon curls and serve them with tasty nuts.

TREAT THE KIDDIES TO A MOVIE Indulge your guests with a relaxed environment free from the blare of the television and endless telephone calls.

DRESS UP Just because you're the hostess doesn't mean you can't wear that fetching cocktail hat.

Ham Biscuits

Ahh, ham biscuits: We call them the chameleons of cocktail food because they work equally well at a fancy gathering and the most casual get-together. These would also be good made with smoked turkey instead of ham. Brushing the tops of the biscuits with butter before baking isn't necessary, but it will give them a deeper golden brown color.

MAKES ABOUT 14 BISCUITS

BISCUITS

2 cups all-purpose flour

1 tablespoon baking powder

½ teaspoon salt

6 tablespoons (¾ stick) cold unsalted butter, cut into ½-inch cubes

⅔ cup milk

2 tablespoons unsalted butter, melted

2 tablespoons unsalted butter, at room temperature

½ pound thinly sliced smoked ham

About 1 tablespoon Dijon mustard

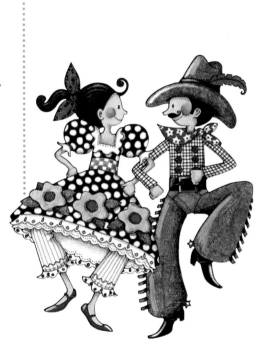

1. Make the biscuits: Preheat the oven to 425°F. Grease and flour a large baking sheet.

2. In a large bowl, whisk together the flour, baking powder, and salt. Using a pastry blender or two knives, cut in the 6 tablespoons butter until the pieces are the size of tiny peas. Using a fork, stir in the milk just until a shaggy dough forms.

3. Turn the dough out onto a lightly floured surface and knead briefly just until a ball of dough forms; do not overwork the dough. Quickly pat the dough out into a ½-inch-thick round. With a 2-inch round biscuit cutter, cut out as many rounds as possible from the dough and place 1½ inches apart on the prepared baking sheet. Gather the scraps of dough and knead together briefly; pat out and cut out more biscuits. If desired, brush the tops of the biscuits with the 2 tablespoons melted butter.

4. Bake for 14 to 16 minutes, or until the biscuits have risen and are lightly golden. Cool briefly on the baking sheet on a wire rack. The biscuits are best right after baking, but they can be made up to 4 hours ahead, cooled completely, and stored in an airtight container.

5. As soon as the biscuits are cool enough to handle, split them horizontally in half. Brush the cut sides generously with the butter. Divide the ham into two stacks (no need to separate into individual slices) and pull or tear the ham into biscuit-sized pieces. Mound the ham on the bottoms of the biscuits, spread it lightly with mustard, and top with the biscuit tops. Serve immediately.

Biscuits Forever

Biscuits are the often-overlooked heroes of party menus. Even though they're humble country food, biscuits are usually the guests' favorite! Fill your homemade biscuits with turkey, chicken, prosciutto, even lobster salad. Make sweet biscuits: Before baking, sprinkle the biscuits with sugar; serve them with preserves or honey butter. If you have only one kitchen specialty, make it biscuits!

Chicken Liver Pâté

Here is an easy-to-make pâté fine enough for the most sophisticated palate. Spoon it into an attractive ceramic crock, and serve it with Melba toast, assorted crackers, or slices of French bread.

SERVES 8

1 pound chicken livers, rinsed and trimmed

½ cup (1 stick) unsalted butter, at room temperature

1 onion, minced

¼ teaspoon dried thyme

1 tablespoon Cognac or other brandy

1 teaspoon salt, or more to taste

2 tablespoons heavy cream

1½ tablespoons green peppercorns packed in brine, drained

Crackers and/or baguette slices, for serving

1. Bring a large saucepan of salted water to a boil. Add the livers and bring back to a simmer. Reduce the heat and simmer gently just until the livers are cooked through but still slightly pink in the center, 8 to 10 minutes. Drain and let cool completely.

2. Meanwhile, melt 1 tablespoon of the butter in a small skillet over medium heat. Add the onion and thyme and cook, stirring occasionally, until the onion is translucent, 6 to 8 minutes. Remove from the heat and let cool to room temperature.

3. In a food processor, combine the livers, onion mixture, the remaining 7 tablespoons butter, the Cognac, and salt and process to a smooth puree, stopping to scrape down the sides once or twice. Add the cream and process until well blended. Add the peppercorns and pulse just until well blended.

4. Transfer the pâté to a small serving crock or other container and smooth the top. Cover and refrigerate for at least 2 hours before serving. Serve with crackers and bread.

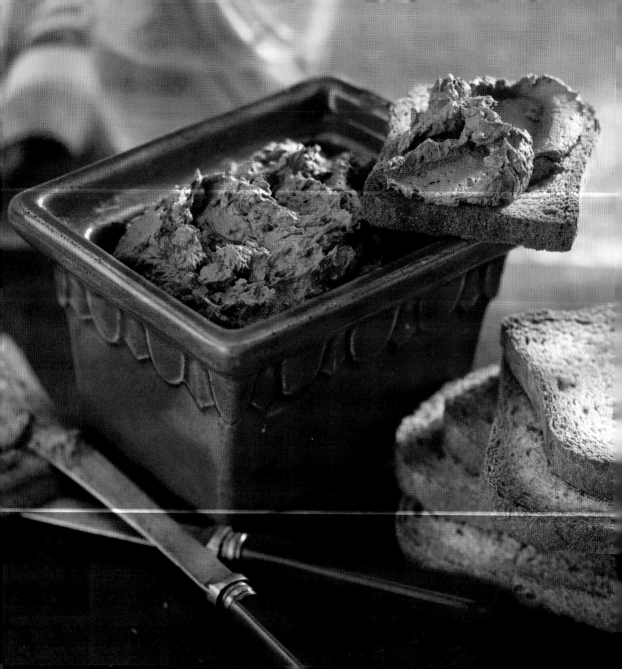

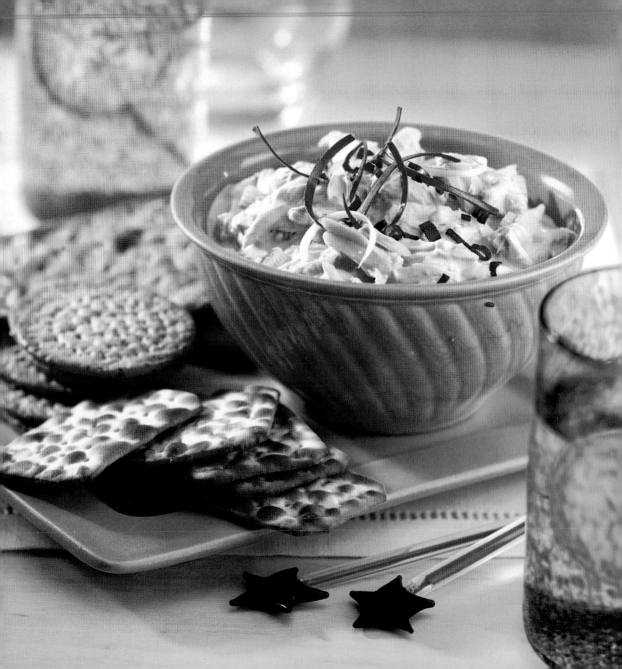

Creamy Crab Dip

Splurge on fresh jumbo lump crabmeat—you're worth it.
If you do opt for canned crabmeat, choose the best quality available.

SERVES 8

One 8-ounce container sour cream

4 ounces cream cheese, at room temperature

3 scallions, white and tender green parts finely minced, darker green parts finely minced and reserved

1 tablespoon fresh lemon juice

5 to 6 drops hot sauce, or to taste

Splash of Worcestershire sauce

Two 6-ounce cans crabmeat, well drained, or 12 ounces fresh crabmeat, picked through for shells and cartilage

Crackers and/or Melba toast, for serving

1. Combine the sour cream and cream cheese in a food processor and process until the mixture is smooth.

2. Transfer the sour cream mixture to a large bowl and stir in the white and light green scallions, lemon juice, hot sauce, and Worcestershire, blending well. With a rubber spatula, gently fold in the crabmeat. Transfer to a serving bowl, cover, and refrigerate for 1 to 2 hours, until chilled.

3. Sprinkle the reserved scallion greens over the top of the dip and serve with crackers.

Smoked *Salmon Pinwheels*

Did someone say cocktail parties should be elegant?
Serve these divine spirals of smoked salmon and seasoned cream cheese
on thin slices of cucumber.

SERVES 8

One 8-ounce package cream cheese, at room temperature

6 tablespoons finely chopped scallions

¼ teaspoon grated lemon zest

Coarsely ground pepper, to taste

8 large thin slices smoked salmon (about ½ pound)

1 small English (seedless) cucumber

1. In a food processor, combine the cream cheese, scallions, lemon zest, and pepper and process until well blended and smooth. Transfer to a small bowl.

2. Lay the salmon slices out on a work surface. With a small rubber spatula or the back of a spoon, spread 2 tablespoons of the cream cheese mixture evenly over each slice of salmon. Starting from the narrower short end, roll up each slice of salmon jelly-roll fashion. Place on a plate, cover, and refrigerate until chilled, 1 to 2 hours.

3. With a sharp knife, trim the ends of the salmon rolls if necessary, then cut each roll into 6 to 8 slices. Place the pinwheels on a plate, cover, and refrigerate until ready to serve; they can be prepared up to 4 hours in advance.

4. Cut the cucumber into ⅛-inch-thick slices; you will need 1 slice for each pinwheel.

5. To serve, lay a pinwheel cut side up on each cucumber slice. Arrange the pinwheels on a large platter or a pedestal cake stand.

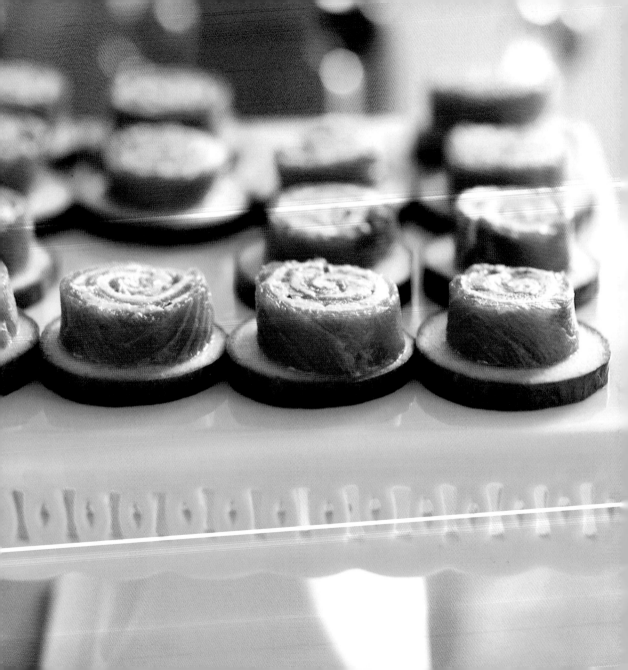

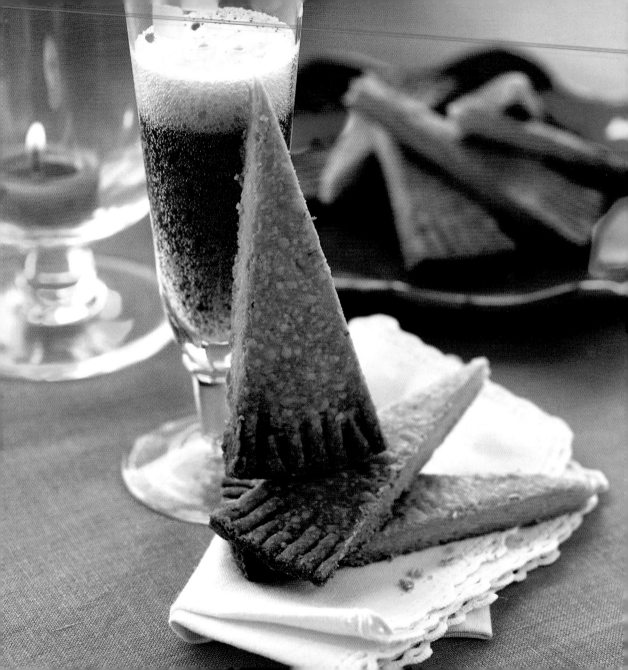

Lemon-Scented

Petticoat Tails

What would a cocktail party be without a sweet little something?
"Petticoat tail" is the whimsical name for triangles of rich shortbread.

MAKES 32 COOKIES

1 cup (2 sticks) unsalted butter, at room
temperature

¾ cup sugar

1 teaspoon grated lemon zest

½ teaspoon vanilla extract

⅛ teaspoon salt

2 cups all-purpose flour

1. Preheat the oven to 325°F.

2. In a large bowl, beat the butter and sugar with an electric mixer at medium speed until the mixture is light and fluffy. Beat in the lemon zest, vanilla, and salt. On low speed, beat in the flour in 2 additions.

3. Divide the dough in half. With your fingertips or a sturdy rubber spatula, press each half evenly into an ungreased 9-inch round cake pan. With the tines of a fork, make a decorative border all around the edges of each round of dough.

4. Bake for 45 to 50 minutes, until the center is golden brown (the edges will be slightly darker); do not underbake. Let the shortbread cool in the pans on a wire rack for 5 minutes. With a sharp heavy knife, cut each round of shortbread into 16 wedges. Cool the cookies completely in the pans on the rack before removing them from the pans.

Margaritas by the Bucket

Fresh, not bottled, lime juice is the key to great margaritas. You can serve these straight up in stem glasses, or on the rocks in highball glasses, as you prefer. If you want that authentic tropical look, frost the glasses in the freezer for up to forty-five minutes before salting the rims.

SERVES 8

¼ cup coarse salt, for the rims of the glasses

1 large lime, cut into 10 wedges

1 pint tequila

1 cup Triple Sec or other orange liqueur

1 cup fresh lime juice

Ice cubes (about 2 trays)

1. Spread the salt on a small plate. Rub the rims of 8 margarita or martini glasses with 2 of the lime wedges. Dip the rim of each glass into the salt to coat. Set aside.

2. Combine the tequila, Triple Sec, and lime juice in a large pitcher. Add ice cubes and stir until the mixture is cold.

3. Strain the margarita mixture into the prepared glasses and serve immediately, garnishing each drink with 1 of the remaining lime wedges.

Bloody Marys

Bloody Marys are so much better made from scratch rather than with a canned product. You can prepare the homemade tomato juice mix ahead if you like: Combine all the ingredients except the vodka, ice, pepper and lemon in a large pitcher and refrigerate until ready to serve. Our version includes plenty of horseradish for a punch. To make nonalcoholic Virgin Marys, simply omit the vodka.

SERVES 8

One 46-ounce bottle tomato juice, chilled

3 tablespoons prepared horseradish

3 tablespoons fresh lemon juice

1 teaspoon Tabasco, or to taste

¾ teaspoon Worcestershire sauce

1½ cups vodka

Ice cubes

Coarsely ground pepper

1 lemon, cut into 8 wedges, for garnish

1. In a large pitcher, combine the tomato juice, horseradish, lemon juice, Tabasco, Worcestershire, and vodka, stirring until well blended.

2. Fill 8 tall glasses with ice. Pour the Bloody Mary mixture into the glasses, sprinkle each with pepper, and garnish with the lemon wedges. Serve immediately.

Index